teNeues

FOR THE LOVE OF
Cats

Anna Cavelius

Translation by Elizabeth Hughes Schneewind

Table of Contents

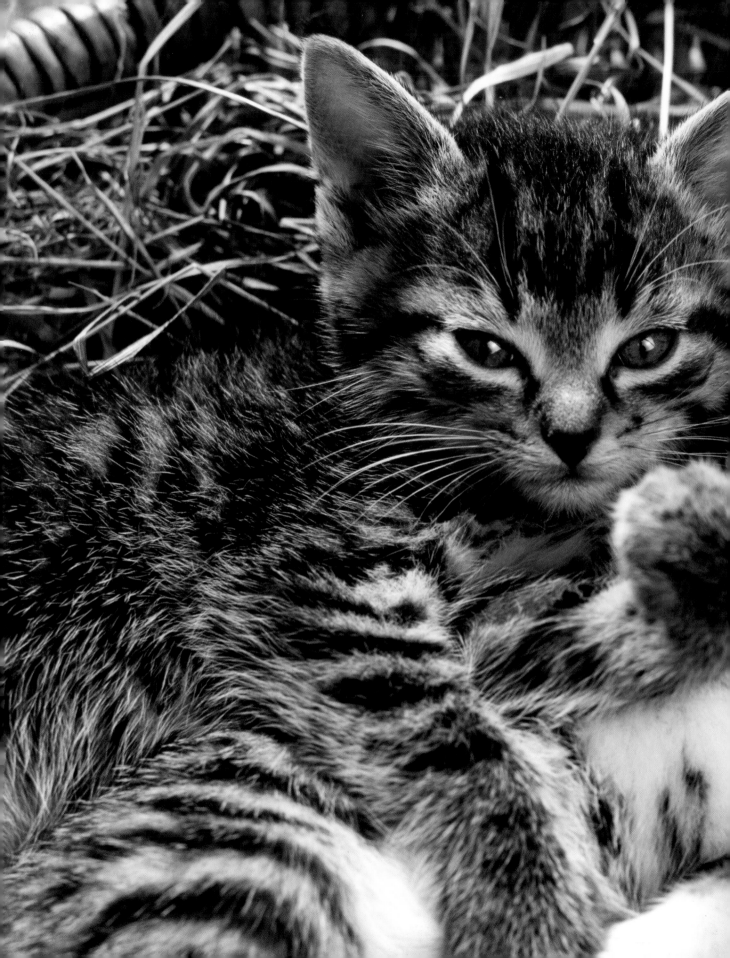

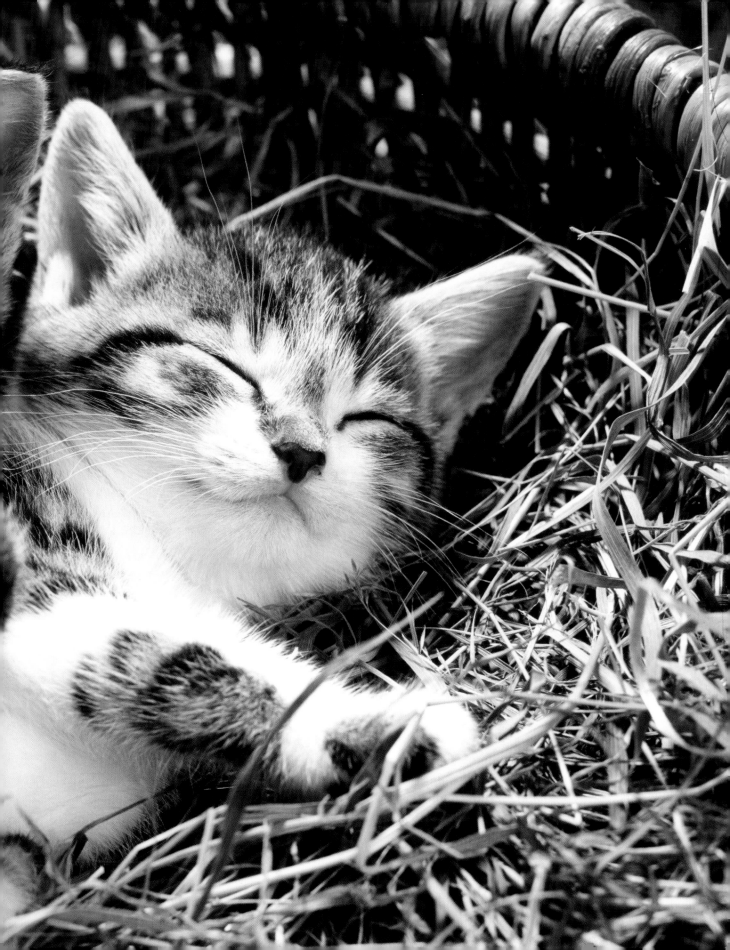

Why I Can't Live Without Cats

On a recent Sunday morning, when I pointed out to my son that he could make good use of the rainy day to improve his Spanish or perhaps practice a few Latin noun declensions, he responded in a melancholy voice, "In my next life, I'll be a cat." He then began a round of snuggling with Cat Number One, who had tidily made herself comfortable on the foot of his bed—this is one of Cat Number One's favorite spots. By the way, we call her Sookie, after the very pretty and also intrepid star in a subversive Emmy award–winning American vampire series. Sookie is the older sister to our cat Thali. I'll come back later to the origin of his name.

Sookie has another favorite spot: my son's desk chair, which is covered with sheepskin. Another spot is the living room couch; its cover has been mended three times by our very helpful seamstress, who has not failed to point out that I'll need a new cover the next time around, as the cats have over the years made a hash of the current one. Yes, and then there's the place in the closet on my older son's winter sweaters. But no matter where Sookie lies she looks unbelievably pretty, elegant, and somehow decorative, even on the threadbare once-upon-a-time designer couch. This comes not only from her beautiful mother, a British shorthair (father, unknown), but also from her own distinctive character. For shy as the little one is and much as she belongs to the class rat teaser (see p. 99), she has bonded with us and our way of life. Incidentally, Thali is good looking, too. He prefers high cabinets and the end of my bed or that of the man of my heart, who has not become a convert and tosses him out. But the little one is stubborn.

I would never, never have acquired one cat, let alone two cats, if I had had any idea that cats casually take over everything in a home, demanding ownership and converting everything to their needs: for a chosen place to sharpen their claws, for a mouse camp, or a place to kill mice, vomit, or give birth. For I really like things around me to be nice. I can't understand why Pablo Picasso said cats are the most considerate company one could wish for. But maybe he was too busy to notice how pumas had taken over his studio. →

My cats are charming, beautiful, and graceful, but never considerate. Whether I like it or not, they pop up whenever they want with dead birds, dead mice, and occasionally a rat, all in a state that I do not wish to describe here in detail. They don't care if I have a deadline or have to take a child to the dentist. When present, they wish to be seen and cuddled, fed, praised, or, for that matter, even scolded a bit for having reduced the population of birds in our garden or of water snails in our neighbor's pond. (That's a specialty of our male cat, who prefers slower prey.) The cats want me to abandon my favorite armchair so that they can make themselves cozy in front of the television in the evening. And they don't want the food from the little bag with blue stripes but only from the one with pink and bright yellow stripes—and they know how to use that silent meow.

In spite of it all, we wouldn't do without them. We simply can't imagine a life without our cats anymore, even though we wept over the loss of their predecessors and even though I swore each time that I would never fall in love with a cat again because it is so painful to part with them. Because cats are irresistible; they are there for us, even if they only do what they want. They comfort us when we are sad, have heartache, or are sick. They make us laugh, because they think up the most extraordinary games and are capable of actions so astonishing that an acrobat in the Chinese state circus would pale with envy. They move us because they like to be with us, even though we can't do much except open cans and pet them and are, in their eyes, feeble-minded. And they bring us peace when the storms outside rage again. In short: this wild untamable domestic animal with its distinctive way of life, makes us richer and happier. 🐾

How We See Cats

<u>The Scientific Viewpoint</u>: About sixty-five million years ago the forefathers of the domestic cat of today, the so-called felines (in Latin *Feloidea*, *Feliformia*, or *Aeluroidea*) lived in Europe, Canada, and China. Hard to believe, yet true: the results of new research have shown that our sweet little house cats (*Felis silvestris catus*) stem from the same ancestors as the canids (*Canoidea*).

<u>History</u>: How the domestication actually came about remains somewhat mysterious. It is certain that our ancestors of the New Stone Age were already dealing with cats and had such a strong attachment that they gave them a burial. It will not surprise the lovers of silky paws that the female cat was once promoted to divinity. That occurred in ancient Egypt some four thousand years ago in the form of Bastet, the most important goddess, who was the epitome of joy and love, beauty, femininity, charm, and fertility. People could hunt dogs, throw things at their heads, and even eat them. But anyone who insulted a cat soon lost their head.

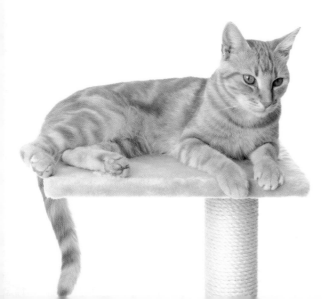

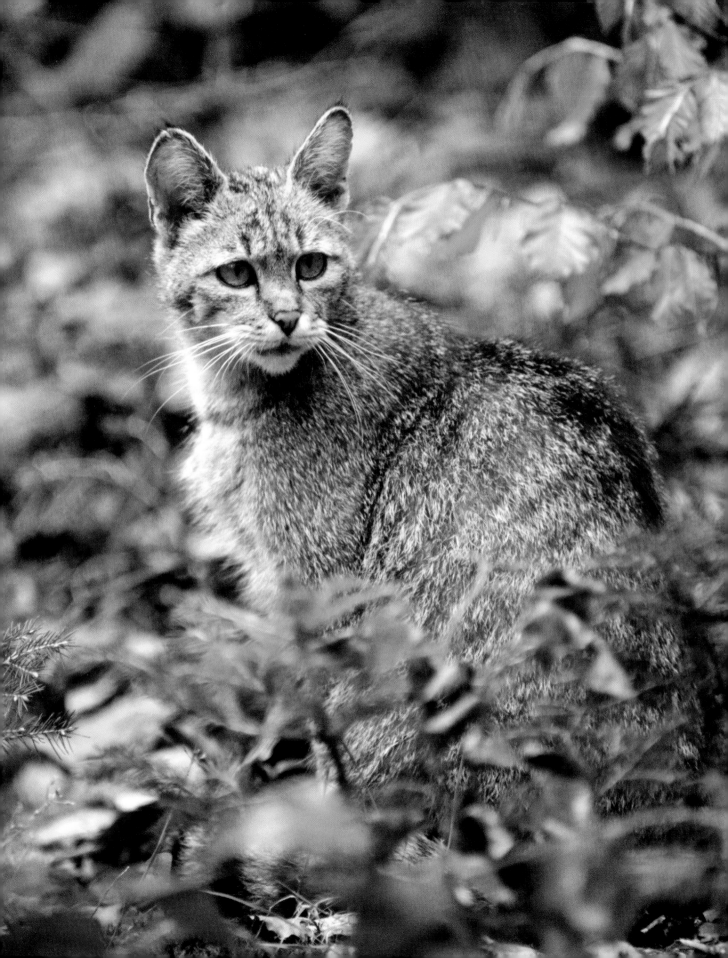

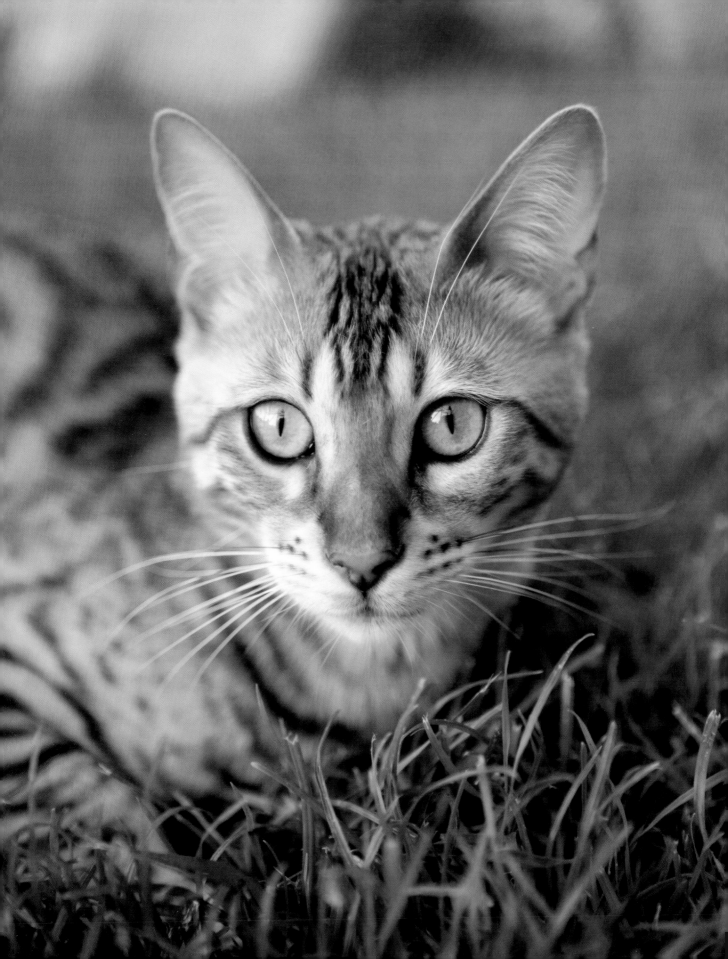

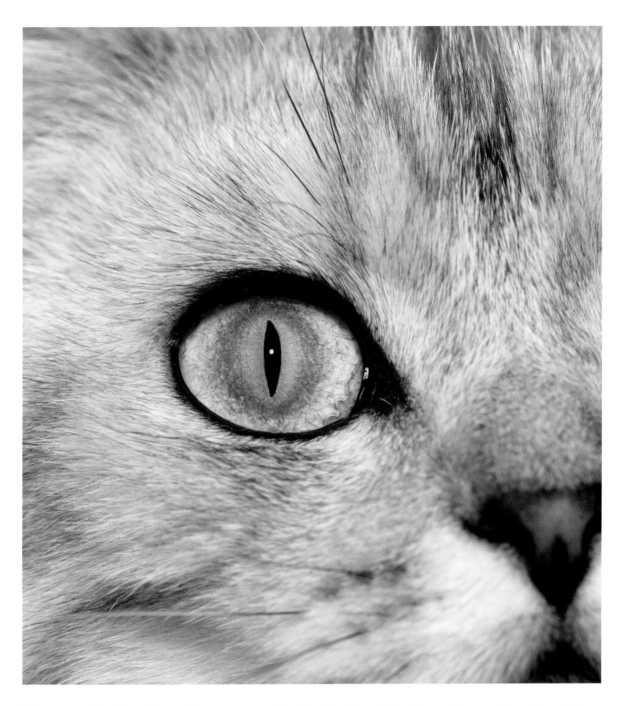

<u>The eyes of a tiger:</u> Yes, cats are more visual animals, unlike dogs, who are "smellers." They overlap just a little with us humans, who belong to the same family. In normal lighting conditions we see just as well as they do. However, cats are ahead when it comes to farsightedness: from three hundred feet away they can distinguish which of two people is their can opener. In worse light they even see twice as well as we do and also have wonderful, magical twinkling eyes that glow in the dark.

Killer teeth: So sweet when they are asleep, but then we can see their sharp fangs on the side. And when they open their mouth and yawn so charmingly we can see that they are true mini-killer pumas. With their fangs and teeth they can kill and dissect mice, blackbirds, or rats—after they have played with them, of course. But first they must learn the fatal bite, and some house cats never learn it. (By the way, Sookie's little brother Thali is no house cat, but has never mastered the fatal bite, which leads to a certain potential for sibling jealousy.) The cat who knows that fatal bite though knows it inside out.

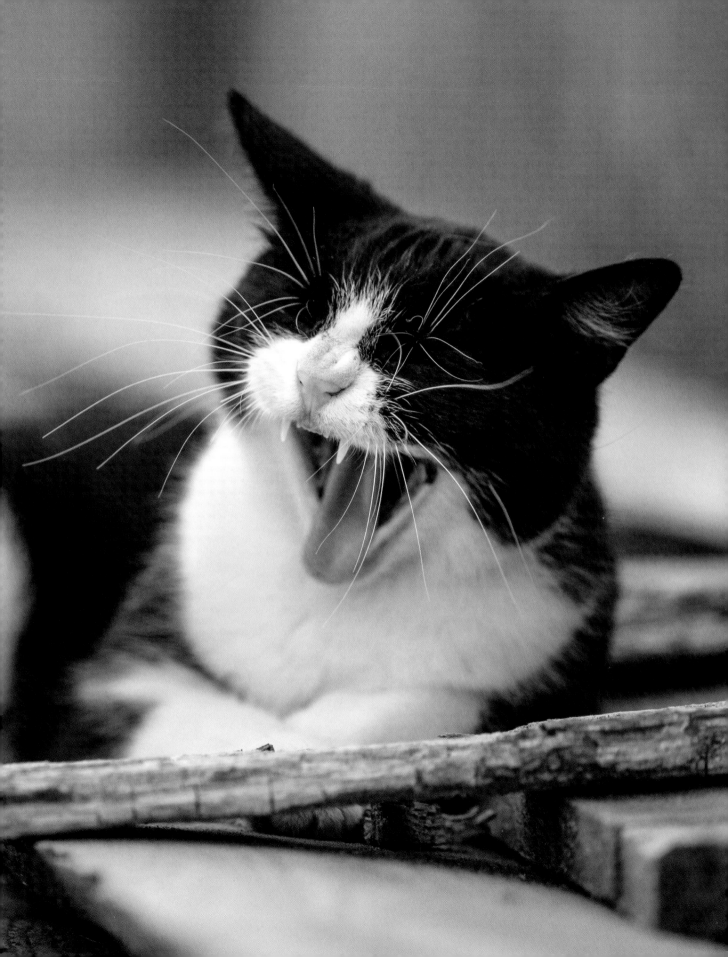

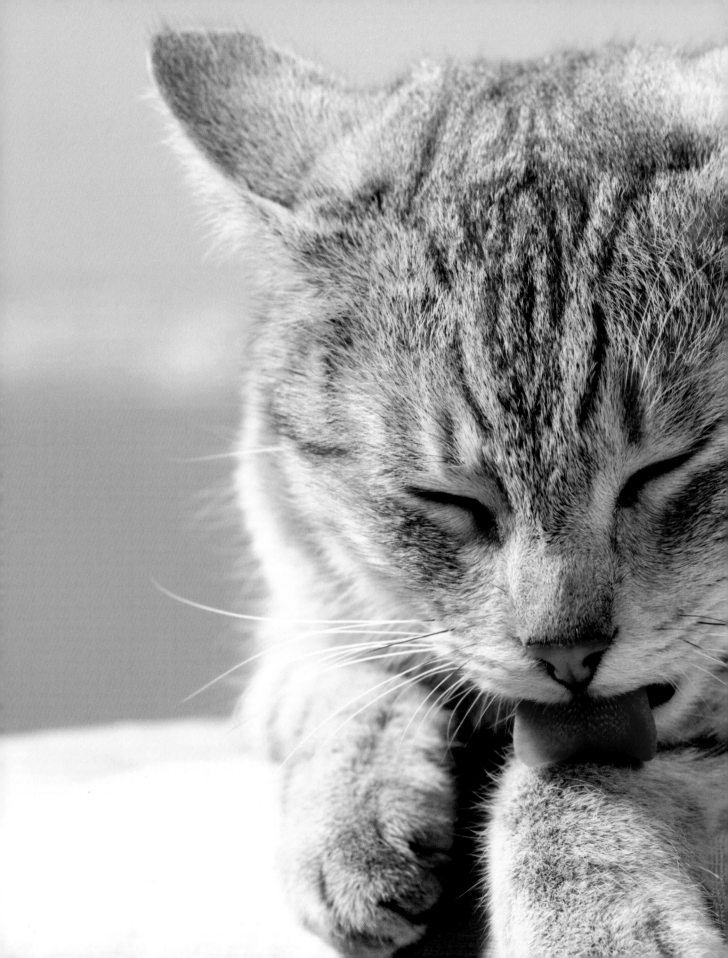

Cats' tongues: Practically nothing is as amusing as cats licking us with total focus with their little sandpaper tongues. This happens when we have touched something tasty (fish, crabs, cooked ham) and smell nice and clean. What counts as nice and clean varies from cat to cat and stretches from an aversion to certain perfumes or aftershave lotions to the smell of onions, nicotine, or alcohol. With their wonderful tongues cats can scrape bones clean and they use them as washcloths, massage gloves, and combs and brushes with built-in moisteners— on every part of their body—which may make us wonder if it is really so amusing to be licked.

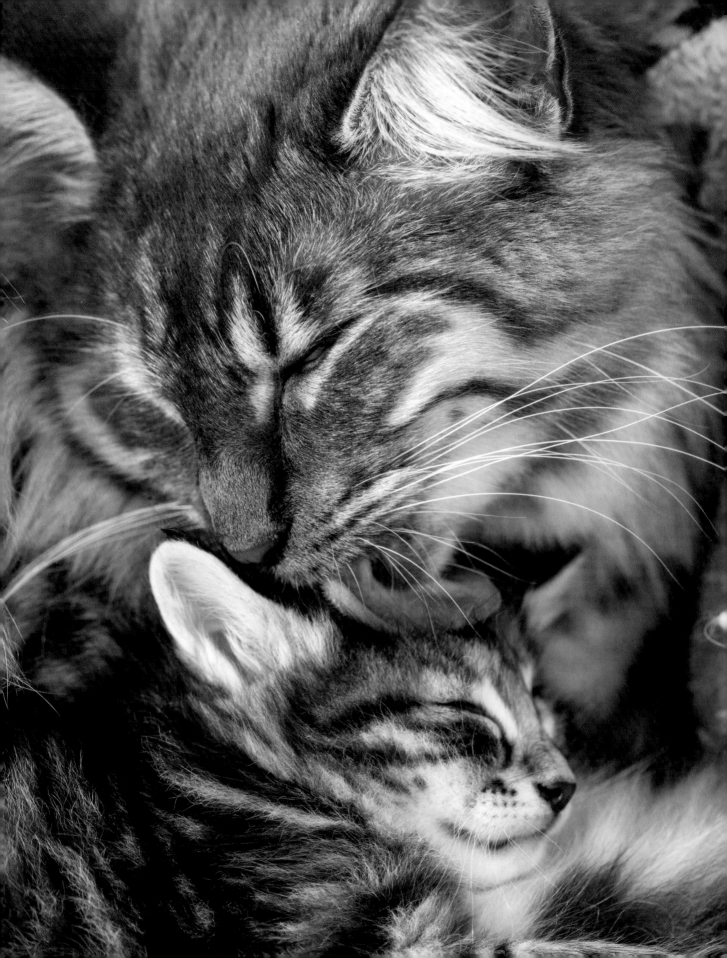

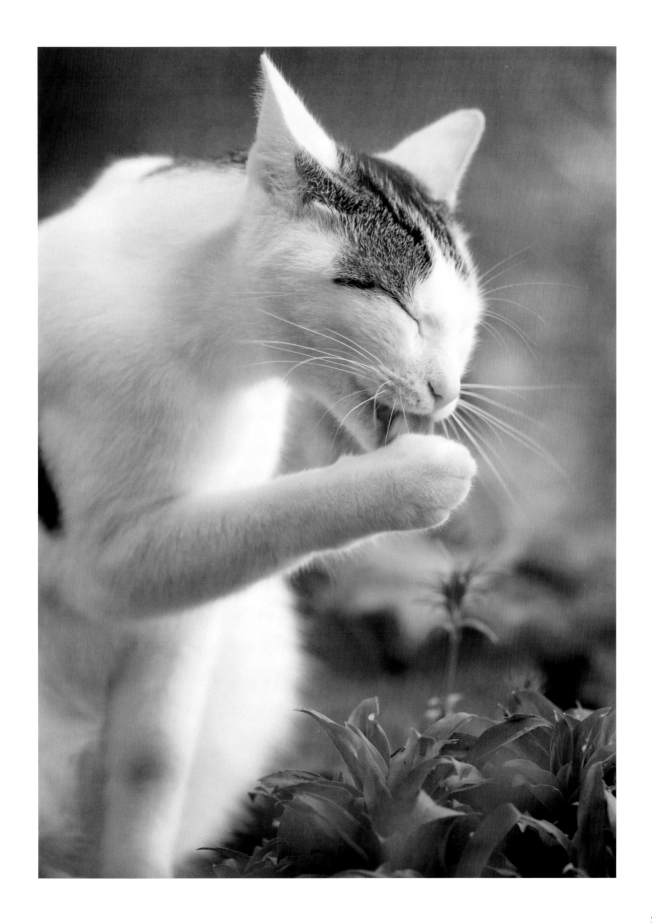

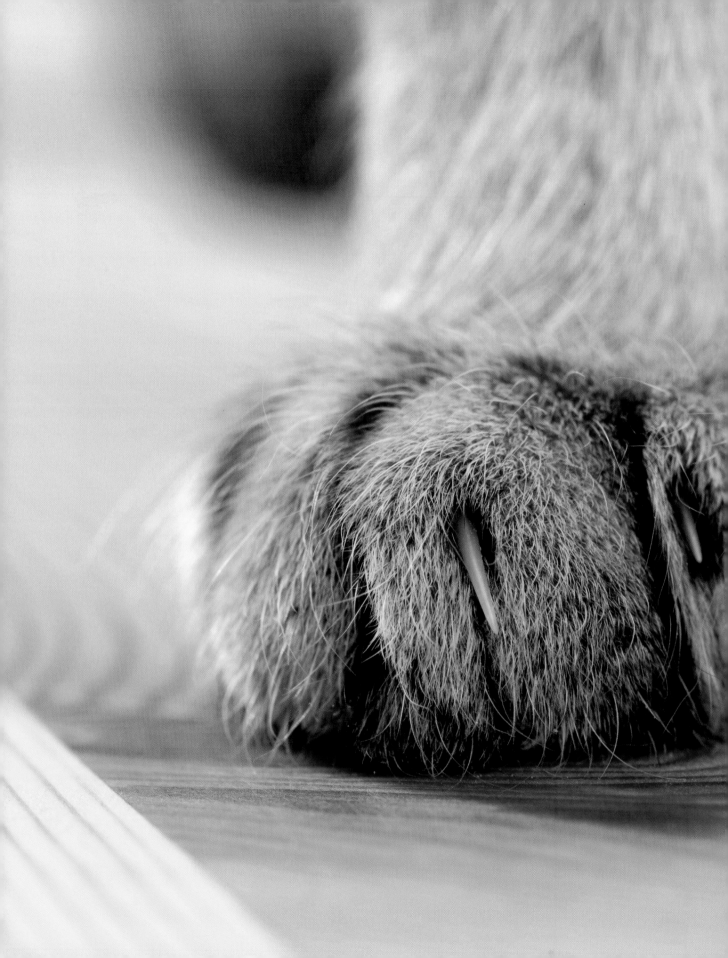

Claws: Cats can extend and sharpen them at will. Claws are magically attracted to every sort of furniture (including antique furniture, pianos, and upholstered chairs and sofas) as well as trouser legs, calves in general, and opaque stockings. And only the claws of her front paws are used while she whets her back paws with her teeth. Cats greatly enjoy the sharpening of their claws; it reduces stress and offers additional relaxation in their restful daily life, which already consists of an average of 16 hours of sleep.

A bat's hearing: Well, maybe that is a slight exaggeration, but cats have terrific hearing, even better than a dog's, and their hearing works even when they are in a deep sleep. Because they can move their ear muscles independently of one another, cats are able to pick up noises from the most varied directions without moving their heads. Oddly enough, what they can't hear so well is their name, when they are called, scolded, or asked to come to us.

Digestive system: Unfortunately, it must be admitted, in fairness to dogs (see p. 43), that feline flatulence can resemble an attack of poison gas and that their excrement also has something definitely toxic. This is known to everyone who has unintentionally walked past a recently used litter box or has instead gone near a flowerpot which a cat has converted to a toilet.

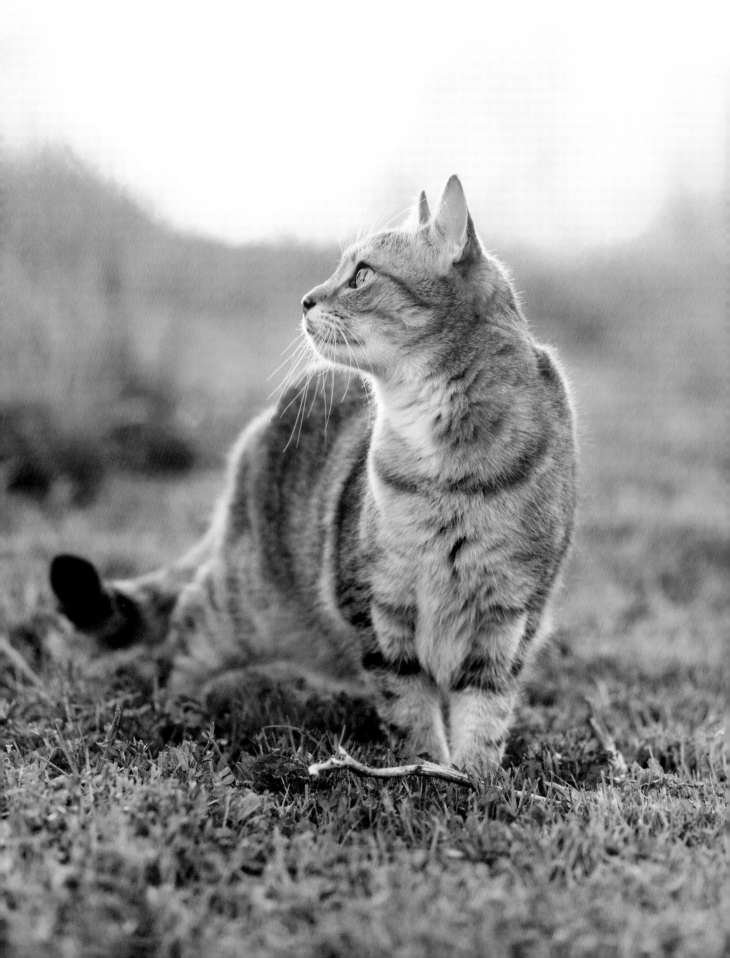

How Cats See Us

<u>The Scientific Approach:</u> To cats, people are *Homo sapiens sapiens*, or large, mostly hairless can-opening slaves that come in various sizes and tones of voice. Sometimes they smell good; sometimes not. People spend a lot of time away; they hardly sleep and muddle around a lot when at home, making a lot of noise while they are at it, for instance, when vacuuming and speaking on the phone. They also spend a lot of time sitting at the computer making funny movements with their fingers on the keyboard. You can make yourself quite comfortable on the keyboard, but then people pick you up and throw you down. After that they type a bit more hectically and mutter things such as, "Darn it!" Smaller people (children, see p. 29) often sit in front of their tablet-PC or look at their smartphone. If they do it lying down, it is very easy to distract them by licking their ear or their face. You can also make small attacks on their toes, often quite humorous even though accompanied by loud noises. Important: people aren't good at bending, even if they do yoga, and they can't reach their bottom with their head.

Differential Diagnosis

Important: *Men* will do anything for you if they think you love them. Then they'll make cozy cuddler beds and you can choose the most beautiful one. They'll buy the most insanely expensive specialty food, and if you roll up on their laps, they'll stay still the whole time in order not to disturb you. A great trick: watch them when they are bathing or shaving, or just come when they call you.
Unfortunately, *women* are somewhat like cats. That's why they see through us better. We have to use different tricks than the ones that work with men! Yet they have a soft side, making it possible for us to mold the household to our needs. If women are annoyed or excited, don't get in their way.
Children can be the real terror, according to their age, sex, or size of their brain. They carry you around, at worst with your stomach in the air, or they pull your tail. But if they don't belong to this species of monster, they are among the best people in the world with the best places for sleeping and snuggling.

History: More than ten thousand years ago in the Levant, men were molding little clay figures of cats, a somewhat silly habit but quite acceptable as a gesture of adoration. In ancient Egypt men did a good job of giving cats an exalted cult status, including delicious food and cat parties. The worst was the Inquisition, when cats were simply burnt along with alleged witches. But whoever said history was always fair!

Today there are horse lovers (ignore them), dog lovers (the most pitiful), bird lovers (highly amusing), fish lovers (ridiculous), and many other special types in addition to cat lovers (generally a bit feeble-minded, but quite capable of learning).

Physiology

Mouth: Many sounds come from people's mouths. Some even come in the form of your own name or particular commands that you can choose to ignore: "Don't sit on the table." "No, not the curtains." "Don't scratch the sofa." "Now where is my dear little sweetheart got to?" Important: The words, "Time to eat," mean that the bowl is being filled. React to that if you feel hungry.

Ears: Unfortunately not well suited for actually hearing anything. If the person is not looking at you, who are giving a sweet, soft meow or looking deeply into the person's eyes, meow loudly and penetratingly or scratch vigorously a nearby piece of furniture. This will cause a reaction such as, scolding, then stroking, then asking what is wrong or opening the patio door.

Chest and Head: Perfect spots for lying down. The chest offers a calming rocking and rhythmic beat. Depending on its crop of hair, the head is very snuggly.

Legs and Feet: Excellent for practicing climbing and sharpening your claws (see p. 23). Terrific: Surprise attacks, though these are followed by noises. Feet (preferably naked or with socks) are also very good for playing catch. Be careful on the stairs, playing there can lead to even louder noises.

Arms and Hands: The most important parts of people's bodies. With them, they can open cans or bags, stroke you more or less deftly (see p. 36), or knead your ears, or, when you happen to feel like it, hold you in their arms (see chest).

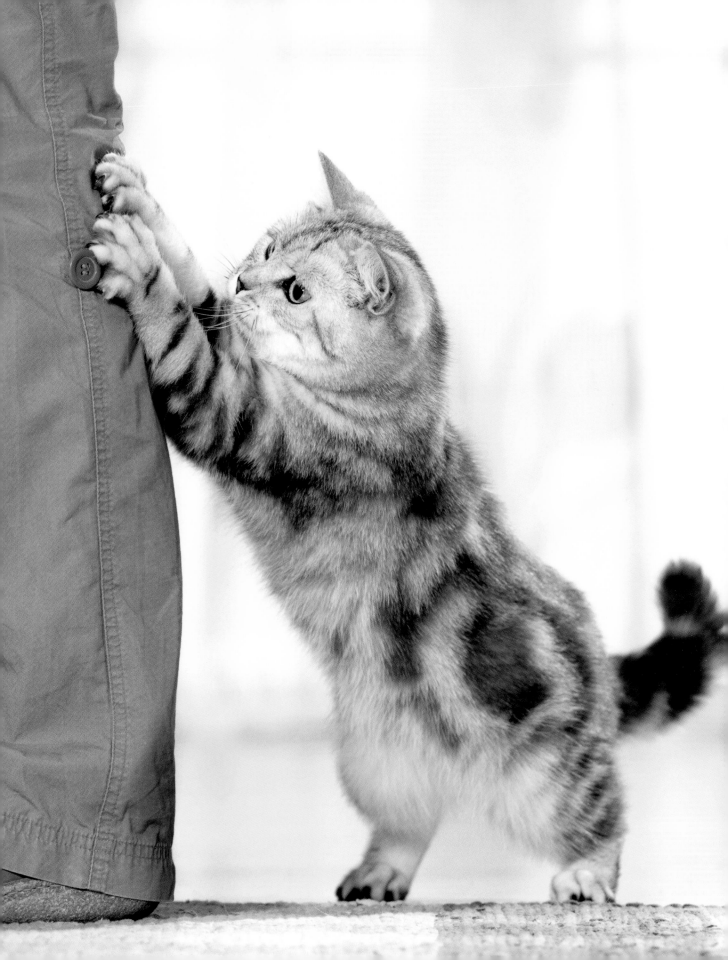

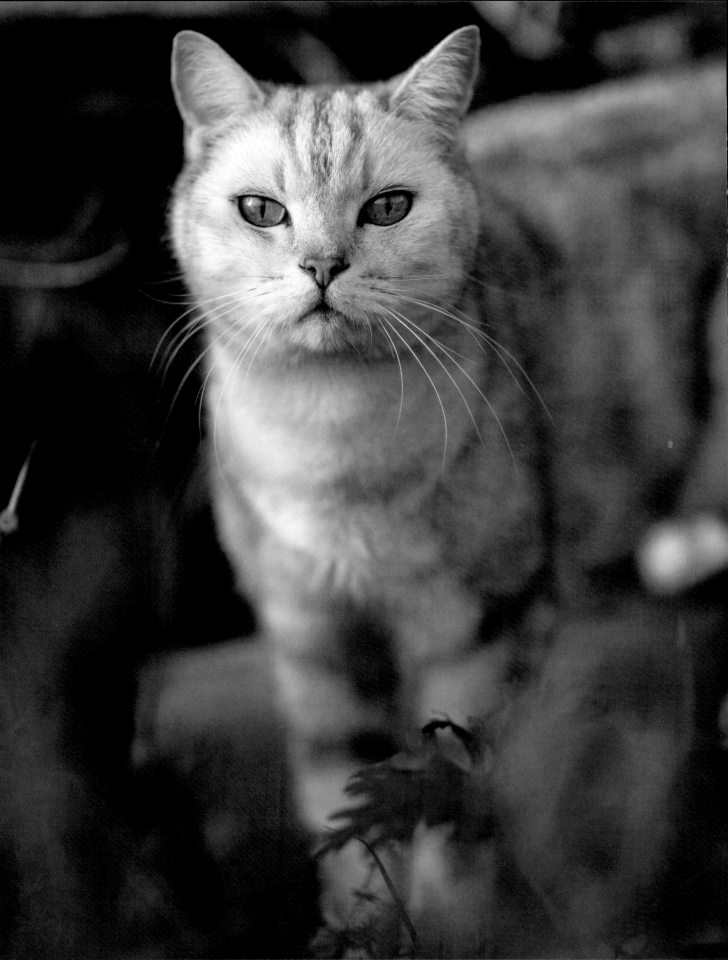

What Your Cat Is Thinking...

Your cat is a wonderful creature. She is wild, yet capable of an intense relationship. She can act very wisely and all-knowingly and is yet like a little child: cuddly, in need of support, playful, and, if we do everything right, extraordinarily trustful and understanding. Furthermore, every cat is strong and free, which can't be said of every person, and we are not always the favorite hero in her life. (We can blame ourselves for this, and anyway every cat is her own favorite hero.) Sometimes, too, we can't understand cats well, even when we try very hard. That is because every cat expresses itself principally through body language, yet if you know how to interpret the signals you can judge her mood correctly. Certain themes in a cat's life are so essential that it pays to take a closer look. This includes the important matter of petting, so underestimated by can openers, the complex theme of dogs, the trauma of veterinarians, and that horror, Christmas. 🐾

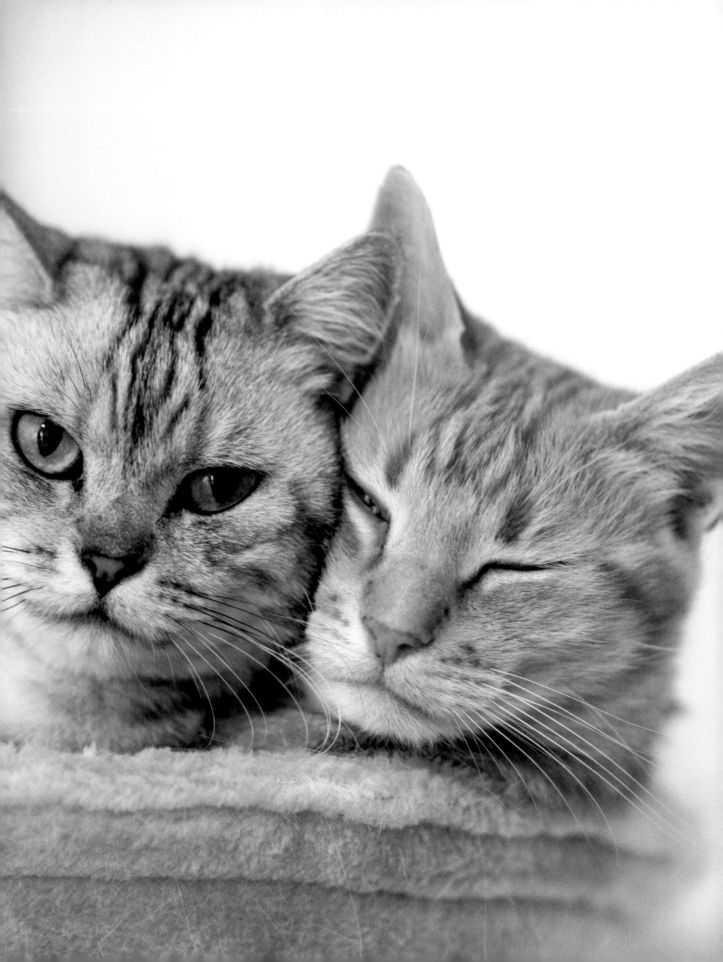

About Proper Cuddling

Here are the most important points that you must note on the topic of cuddling.

First: It is not you, but the cat who determines when she wants to be stroked. Unambiguous signs may be rubbing your legs, but this can also mean that your cat is hungry or bored or that you should open the door because she doesn't feel like using the cat door. Other signs are rolling on her back and offering her furry tummy. However, be careful! Petting attempts in this place can lead to very painful consequences if your cat tries to show you her cat-and-mouse grip. Scolding is not allowed, since you are guilty for falling for this trick. Another sign may be lying on the table, newspaper, keyboard, or book, and giving a penetrating look. But this can also be a sign of boredom or of simply exercising the motto of a master: I can do it, therefore I am allowed to do it.

Second: Never slap, pound on, or knead your cat. The effect: the cat will disappear and won't have a very high opinion of you, you ignorant petter! In the worst case she will lay back her ears; then pull your fingers out of the way.

Third: If you are a really good back rubber, rubbing rhythmically, gently, not too roughly or too softly, you will be rewarded with purring since you are a cat-cuddling master. Never stop petting as long as your cat doesn't want you to. She will give you a signal when it is enough by getting up, jumping off your lap or the keyboard, stretching, or biting your hand.

Incidentally: Having no time to cuddle with your cat is not acceptable. Your cat will insist upon this form of devotion or will otherwise amuse herself with you in other ways: scratching the furniture, hoping up on the table when it is set, tearing up the newspaper you still want to read, using your calves as a scratching post, and so forth. 🐾

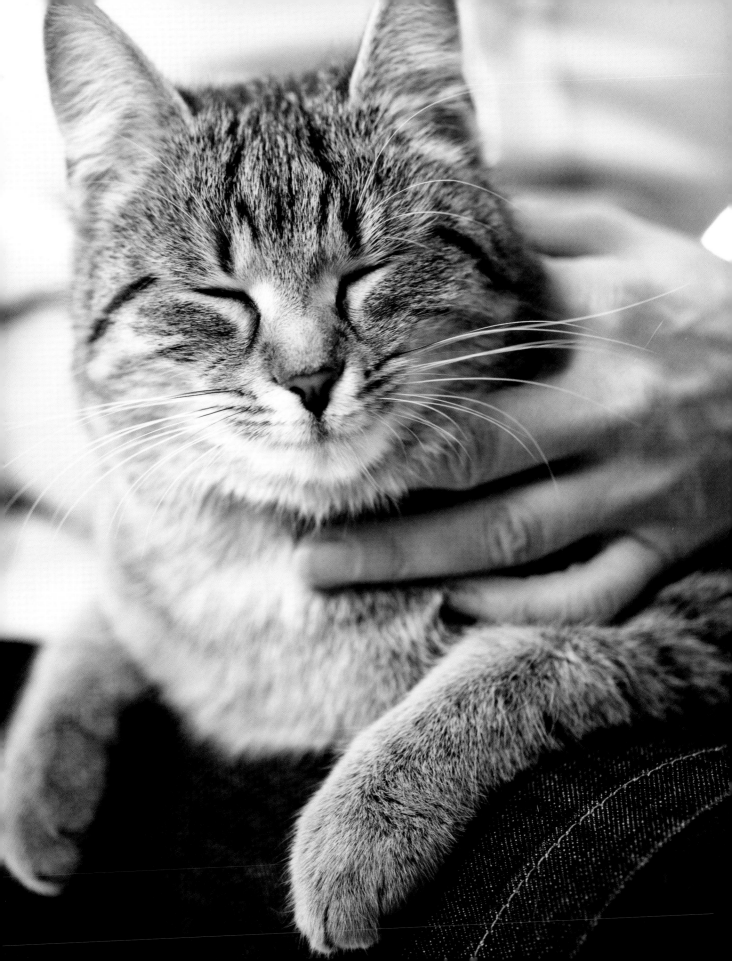

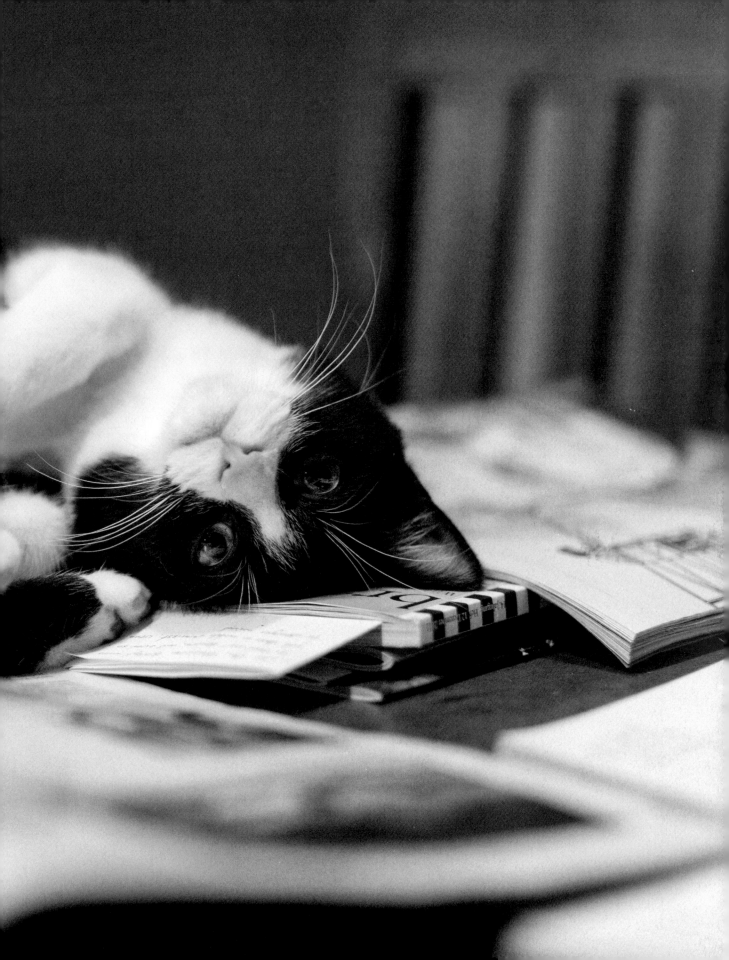

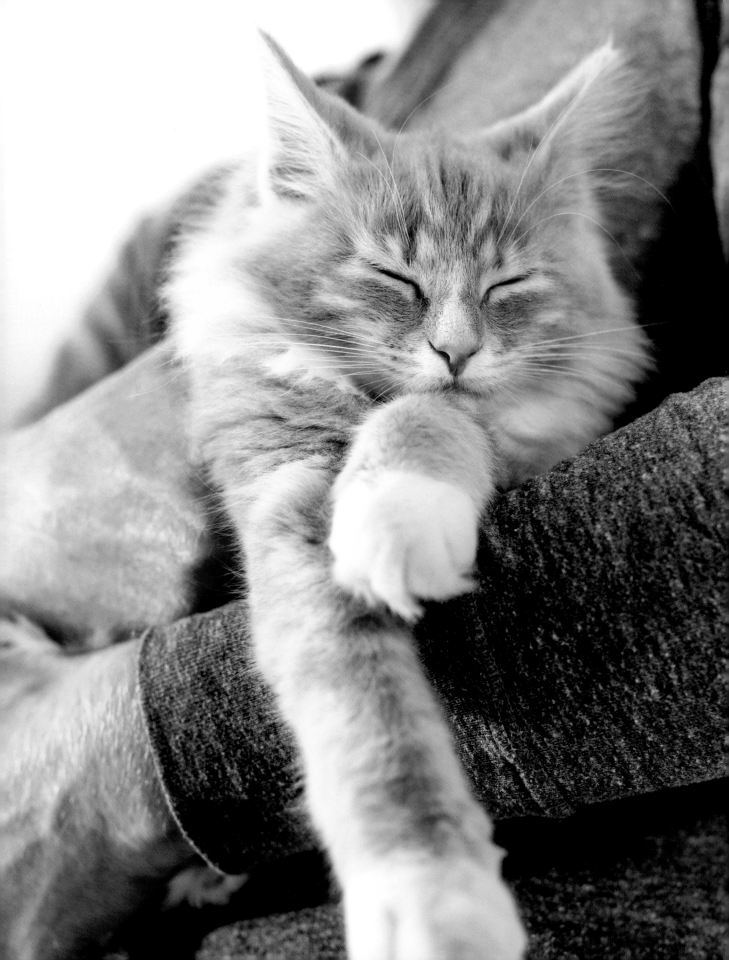

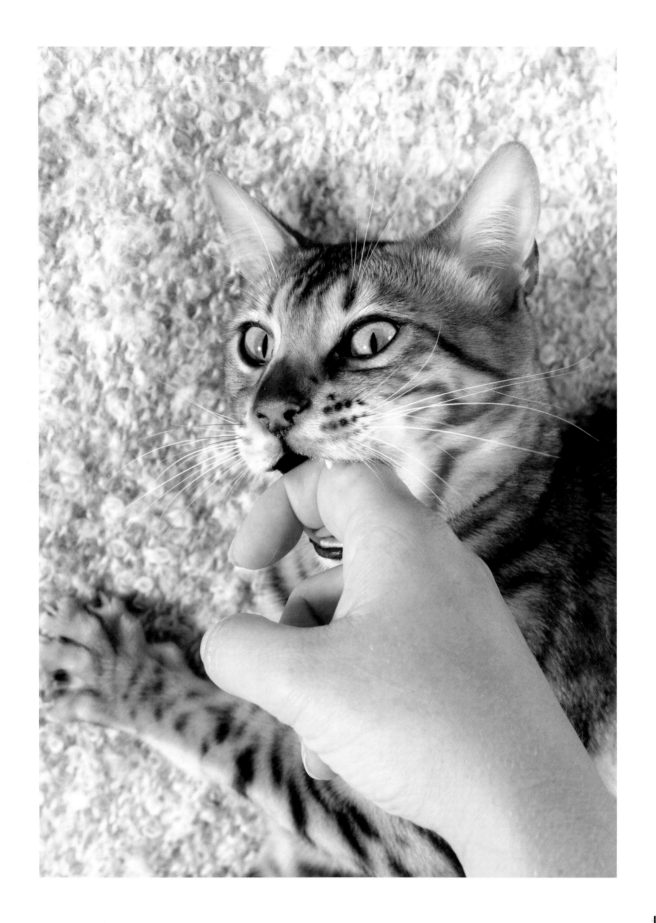

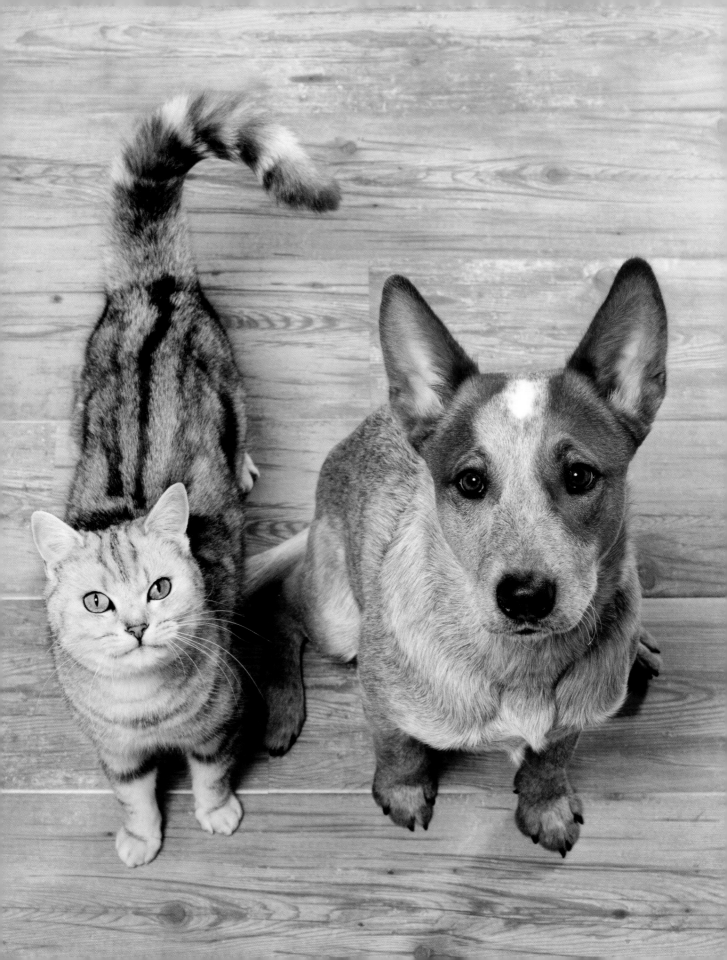

About Dogs

In the eyes of a cat, dogs are unnecessary for the good life. To be sure, there are worse things (see veterinarians and Christmas). But whether a golden retriever, a Labrador, or a pug, anything that barks is simply superfluous and totally incomprehensible. I know that because I have been socialized to both cats and dogs. I was raised with both species, loved them both, and can paint a quite exact picture of both. In the end it is the same as with siblings for whom you never asked for. My oldest son was four years old when his younger brother, who always began his screaming hour between nine and ten o'clock, would suddenly noisily make his presence felt in the house. The older would ask in frustration, "Mama, can't you give him back?" When I said I couldn't and caressed him comfortingly on the head, my sensible little son suggested simply throwing his little sibling in the garbage. Of course I could not fulfill this wish either, even though the screaming was really quite taxing.

Relations between the four-legged purrers and howlers mostly take the form of the same special relationship between siblings, although peaceful coexistence can sometimes be observed. If a dog moves into a family's household, the cat has only one wish: the can opener should please give this strange, clumsy creature back to the place it came from as quickly as possible. As all house cats know since birth, dogs have the most unpleasant characteristics: for example, they stink, and unfortunately not only when they come home after a long walk in the rain. Sorry, dear dog lovers, but this is true. A cat can't imagine how a dog can stand having to smell itself all the time. And dogs don't place any great value on cleanliness—all right, so they lick their coats a bit from time to time, but they have never learned to do this thoroughly and extensively in even the most remote parts of their body the way a cat does regularly, and they probably won't learn how to do it in 100,000 years. →

And it must be added, unfortunately, that dogs are weaklings. When they have lost a fight they lie on their back and offer their throat to be bitten by their opponent instead of bravely fighting on or at least fleeing. No cat would show such weakness.

And as if that weren't enough, dogs—and here it gets really disgusting—slobber. They slobber so loudly that cats can hear it all over the house. They also don't know the most basic rules of living together. The tailwaggers don't understand what it means when a cat waves its tail. They mistake spoiling for a fight for friendliness. They don't understand why cats purr. Instead of purring along with them they start to growl for no reason, which brings us to the biggest problem: dogs make noise, whereas cats for most of their lives seek rest and introspection.

Dogs whine if their master or mistress is gone for even a few hours. They woof for whatever reason. And they howl if, for instance, the mailman is at the door, as if someone would be driven away by this laughable noise. In short, dogs are for cats nothing but a deafening affront. But the craziest thing about dogs is that they are glad when someone comes along with a leash and puts it around their neck. Dogs actually obey commands. They like to do what people tell them to, at least if they are well trained. Cats, on the other hand, do only what they want. Occasionally what the cat wants to do agrees coincidentally with what the can opener wants their little darling to do at the moment.

"Dogs have masters, cats have staff," said the German writer Kurt Tucholsky. And the British actor John Cleese, a member of the cult group Monty Python and always ready with a good joke, hit the nail on the head: "All dogs are little Nazis. They always need a leader whom they can admire. They do whatever their little master demands. You throw a stick, they run after it and bring it back." Looking at such games, cats can only think, "How stupid can they be!" A cat would say, "If you must throw your silly stick around for no reason, fetch it your-self if you want it."

This, of course, throws light on the owner. Certainly there are people whom dogs and cats call their own and who live with them more or less peacefully. But most dog and cat people are basically different. Artists and free spirits love cats. Dog owners on the other hand sometimes lack all sovereignty. They try to create an image of themselves in their four-legged friend, whether it is a brawny Rottweiler or a little Papillon with a pink ribbon. A dog who has to drag such an owner around with him basically needs a new master.

Cats are domesticated in order to live with us. They are sociable and basically peaceful even though they remain antagonistic, willful, independent, and unpredictable, unlike dogs, who have always been trained to communicate with people. No cat would ever chase a ball or jump into the water simply because someone takes a notion that she should. Cats are simply more natural and closer to their origins than dogs.

A dog, says the couples therapist and psychologist Lisa Fischbach, "is better suited to the psyche of men, who can tussle with them; the hierarchy is clearly determined." Women are readier to accept that they can't "boss someone around." But because cats are not easy to understand, long-term relationships with them are so much more enriching. Humans learn life-long lessons from their feline darlings. Cats teach us tolerance. Wise cat owners know how to put a good face on when things go wrong. They recognize that giving is more blessed than receiving. They have learned that affection cannot be bought and that they only waste their time if they try to run after happiness, because it will just run away. 🐾

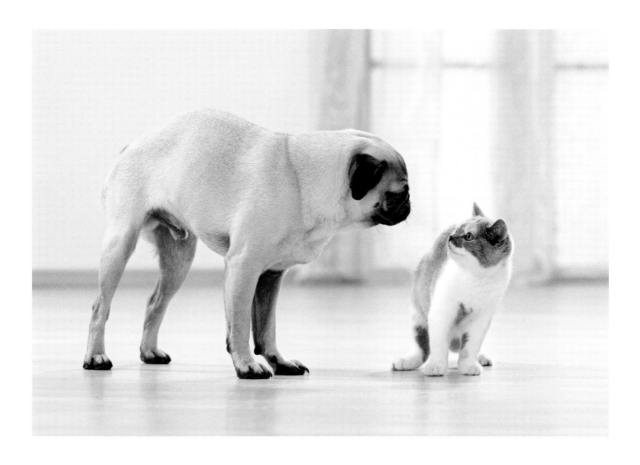

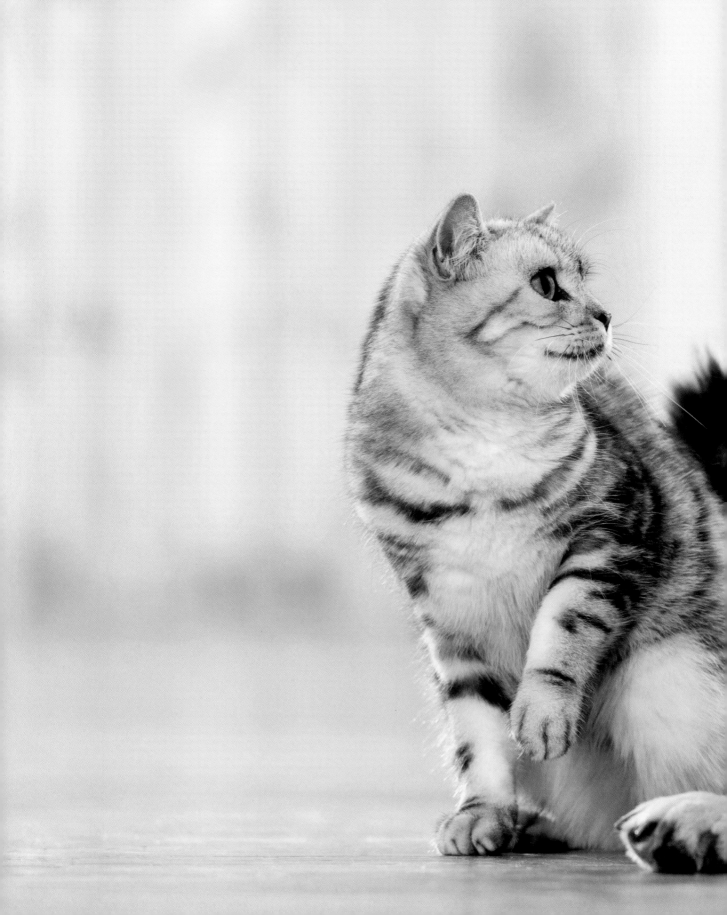

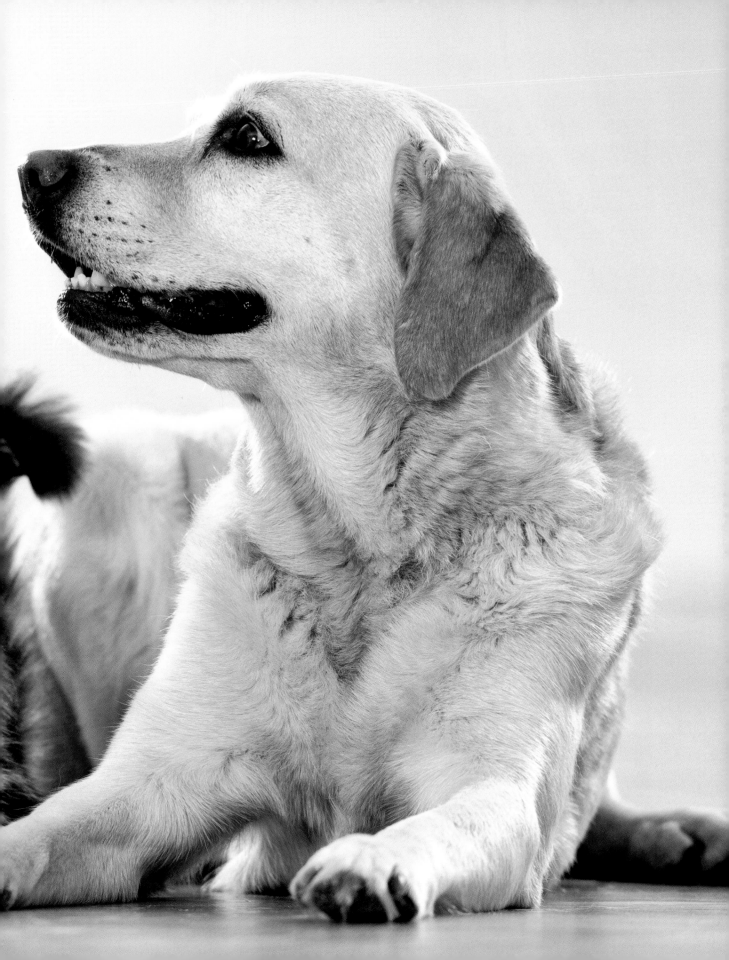

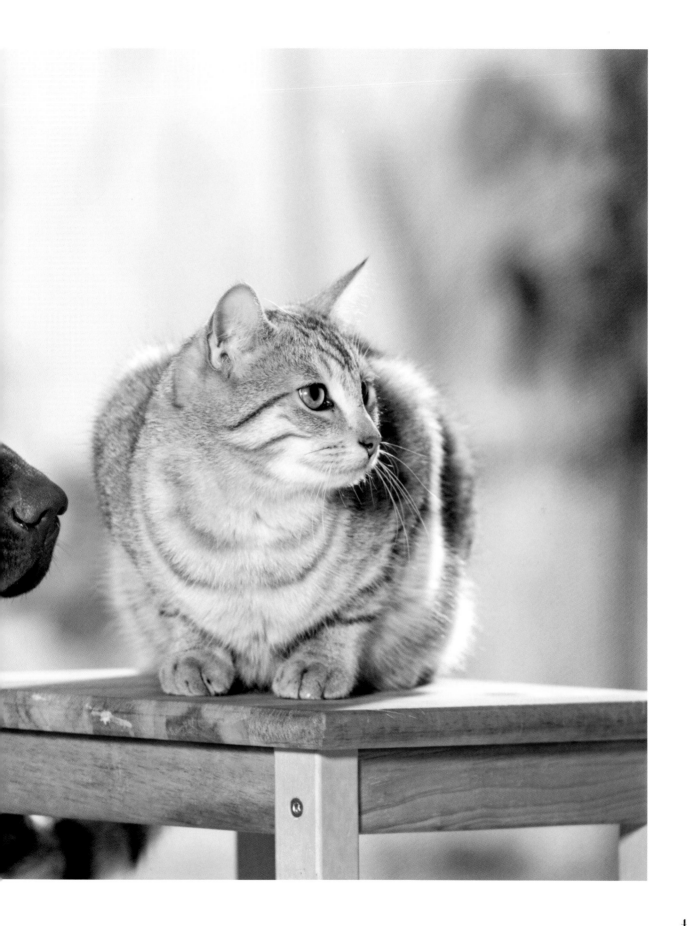

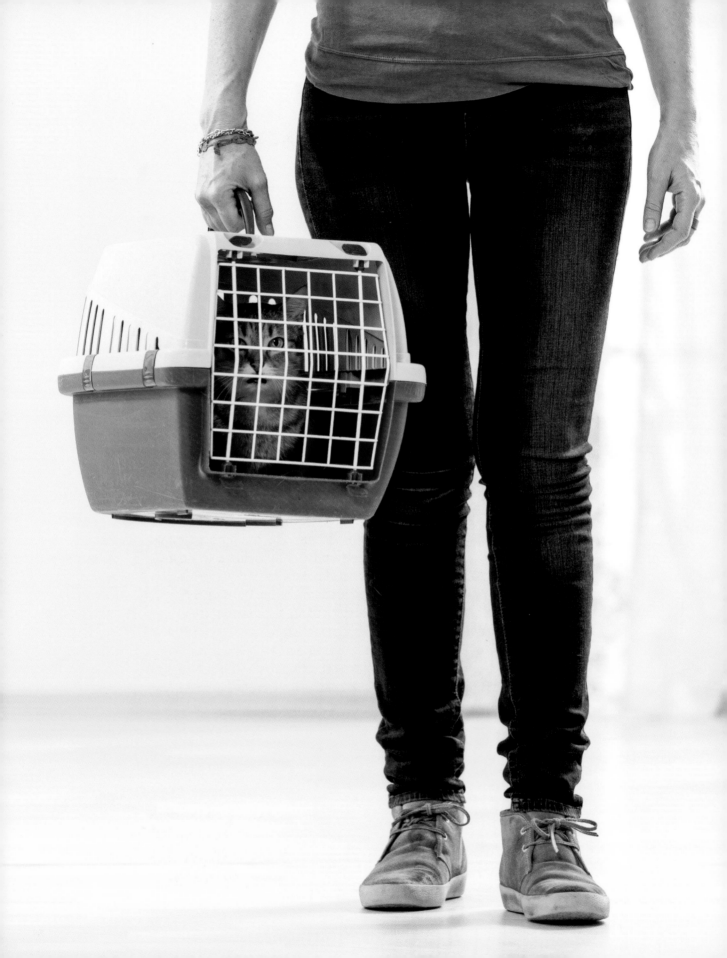

About Veterinarians

It came to light through our veterinarian, who is really a specialist in equine acupuncture but also works with smaller animals. I must do some explaining. Originally our male cat was called Thalia and was a girl. It wasn't me who named her after a Greek muse, nor was it an implicit sign of a good education applied to our four-legged housemates. For I am a cat mother, but certainly not a tiger mother. Responsibility for the exquisite naming of our kitten belonged to my younger son, who at the time was partial to the series, *Percy Jackson*. In the series the young demi-god Perseus, son of Poseidon, becomes attached to the young demi-goddess Thalia, daughter of Athena, a very brave and antagonistic young woman, just like her mother. And it was she who is the namesake of our sweet little black-and-white cat, who in time became a very playful and somewhat woebegone creature rather than a heroine.

As she aged, I began to notice certain changes in her rear that reminded me of our long-dead male cat Luis Figo, but I am a gullible person. If someone tells me a cat is female I am inclined to believe it. Then the time came to take both our cats to our veterinarian to be spayed. When we came to pick them up Dr. W. said, with an amused look in his typical Rhineland singsong, "I haven't spayed one of them." I said, "For goodness' sakes, was she already pregnant?" (Thalia was inclined to wander at night.) "Nope. She is a he." As a new mother of a male cat, I drove home with my cats, still in a fog. We quickly resolved the problem of the name by simply omitting the feminine "a" from the end of the name. Since then our cat has been called after an Indian lentil dish. →

Dr. W. may have brought clarity into our discussion of gender, but the obligatory visits to him are something our cats would cheerfully do without. Unfortunately, Dr. W. occupies the top position in the list of things our cats hate, even worse than dogs and Christmas. That creates a problem, as I am a responsible cat mother who stresses the importance of vaccinations and deworming. Every appointment with Dr. W. is a big adventure for the whole family, requiring certain logistical and psychological arrangements. On the day of days the cat carrier (a.k.a. the death box) appears in the kitchen as if by magic, and both cats know that the hour has come. While Sookie, a very courageous girl, resignedly allows herself to be packed up, Thali generally seeks to solve matters by escaping. Once in the carrier, he begins yowling, from the moment we depart until we arrive in the parking lot. Alas, I have never succeeded in training my cats to calmly ride in the cat carrier. Cat psychologist Katja Ruessel says, "All you have to do is be sure that your cat associates the carrier with pleasant things," or, "If your cat has had bad experiences with the carrier, it makes sense to get a new one that looks as different as possible from the old one." Since my cat is not stupid, he would recognize any carrier as the death box, and I would have the problem of storing endless cat carriers. Sometimes cat psychologists just don't get it.

Dr. W.'s office stinks of disinfectants. The waiting room is full of frightening fellow cats and other animals that our cats would ordinarily hunt, such as rabbits, guinea pigs, and turtles, or would hiss at very effectively, such as any sort of dog. Only people can alleviate the time in the waiting room. The entertainment factor is like that in the waiting room of a general practitioner with many seniors. The question, "And what is the matter with yours?" leads quickly to a professional discussion about psychosomatic issues, homeopathy, vaccines, problems with the ears and teeth, and so forth. Often you'll learn more in the waiting room than with the doctor himself. Meanwhile you calm your cats down and look pityingly at dogs and, yes, even cats whining. →

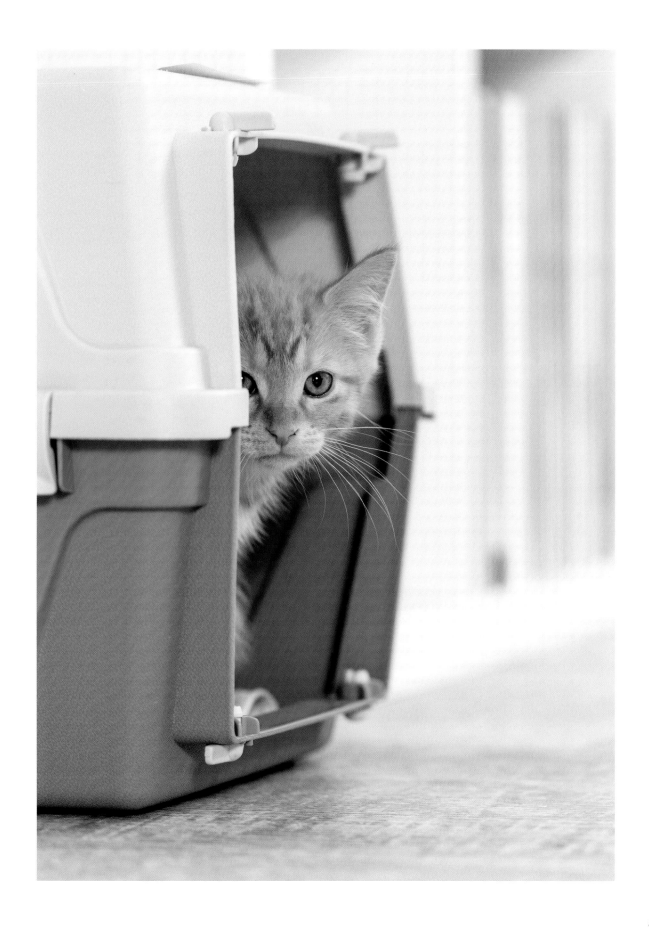

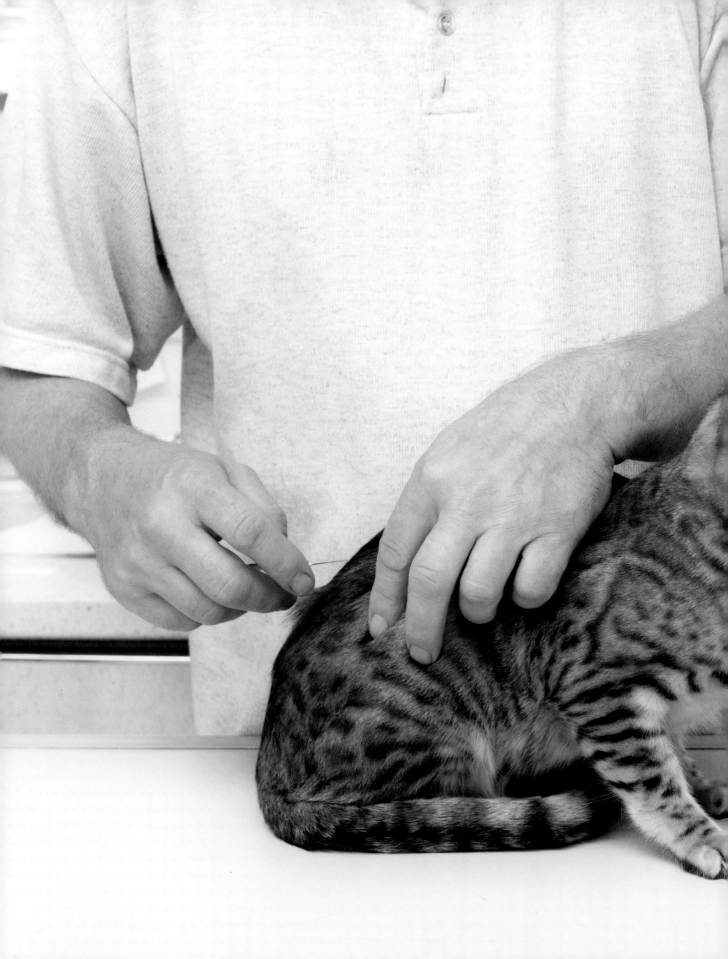

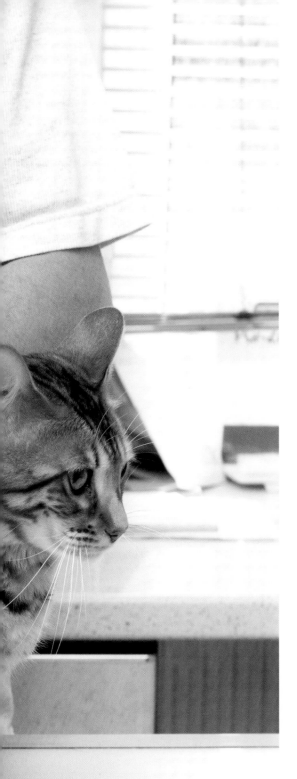

Even my cats are pretty worn out, and when the doctor's door opens they are often quiet, as though they weren't even there. In the exam room the drama starts up again after a certain amount of well-practiced dramatics get going. Sookie lets herself be picked up and vaccinated with some resistance. But with Thali there is a life and death struggle. The last trip was really expensive, as the doctor needed three injections just for him. My two sons, who took on the trip to the doctor this time, were scratched and somewhat beat-up. All four were clearly in agreement that this was their last trip to the veterinarian. Next time it would only be me again. 🐾

About Christmas

Dogs are not the only things cats can do without. Domestic tigers would also rather do without Christmas. What many people regard as the most beautiful days of the year are a feast of distress for our darlings. For them, Christmas means unnecessary noise (outsiders who come crashing loudly into the house), sharp strange objects on the floor (pine needles), unusual smells (candles that smell almost as bad as dogs). Cats would prefer to move out during the holidays. But it generally isn't any better outside. It's usually muddy because it once again hasn't snowed. Or else it is white and ice-cold; snow isn't any better than mud because it burns your feet.

Cats begin to be annoyed around Advent. Mothers are baking, and fathers, children, or grandparents get so hectic that they stop noticing where they are stepping. Even more dangerous are the hot baking sheets lying on the floor in the kitchen to cool off and the oven that is always so hot that cats walking by must fear for their fur.

The whole business would perhaps not be so bad for our darlings if we would at least let them play with our Christmas decorations. But they aren't even allowed to bat the balls on the Christmas tree even the tiniest bit. They might fall and break. Reaching for the tinsel is also not permitted. If a cat eagerly swallows it there are unpleasant consequences for the stomach and bowels. Concerned veterinarians' offices warn against "Christmas dangers for domestic animals." And then there's the tree itself. If it falls over it can quickly set on fire the curtains, the sofa, or the wrapping paper. There is no alternative but to ban cats from the living room during Christmas. →

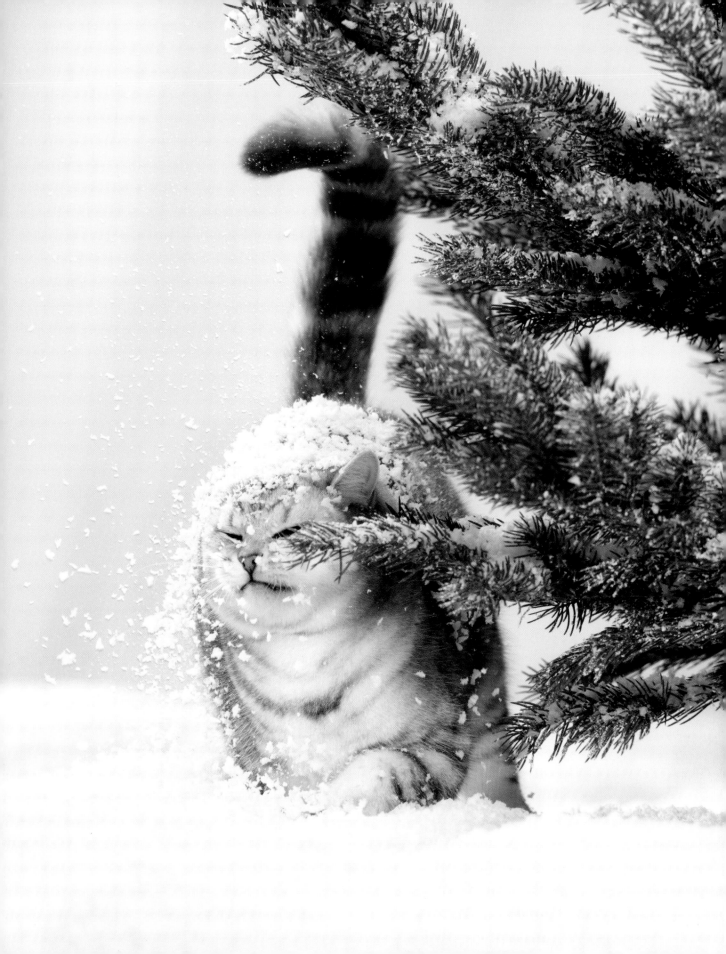

These aren't the only reasons that our darlings thoroughly dislike Christmas. If there were such a thing as news reports or Internet for cats, they would know that many much worse dangers lie in store for them at this season. It starts with the presents: sometimes exotic houseplants show up on the gift table. Even small quantities of amaryllis, fancy lilies, Japanese primroses, and Jerusalem cherry are enough to poison a cat.

Or the little master or mistress turns out to be a human beast. Unfortunately many domestic animals, including cats, are abandoned at Christmas. Although this is illegal in many countries, the owners do this anonymously, leaving the animal in a box directly in front of the animal shelter. For some owners the little animals become an annoyance if no one can be found to care for the four-legged friends during holiday trips.

As if that weren't bad enough, it is quite normal in some parts of the earth to serve roasted cats for Christmas. In Guangdong Province in China as well as in North Vietnam cat flesh is prized in winter for its warming effect. And even in Switzerland cats are still on the Christmas menu. At least in the cantons of Bern, Luzerne, and Jura some families include cat meat as part of the traditional holiday meal.

Beside these grizzly stories there are fortunately happy tales of cats at holiday time. One has to do with the German fashion designer and photographer Karl Lagerfeld. During Christmas 2011 he watched his model Baptiste Giabiconi's little cat Choupette. Lagerfeld and Choupette lived together for two weeks and became inseparable. Lagerfeld didn't give his new love back. Today he describes her as "the world's most spoiled cat." Choupettte has a veterinarian who checks her every ten days from claws to ears. She is allowed to eat at her place at the table; she is especially fond of shrimp. When Lagerfeld travels she often comes, too, along with her specially packed suitcase containing her brushes, important toys, and appetizers. And, oh yes! Choupette has a twenty-four-hour maid. What a life for a cat! ❧

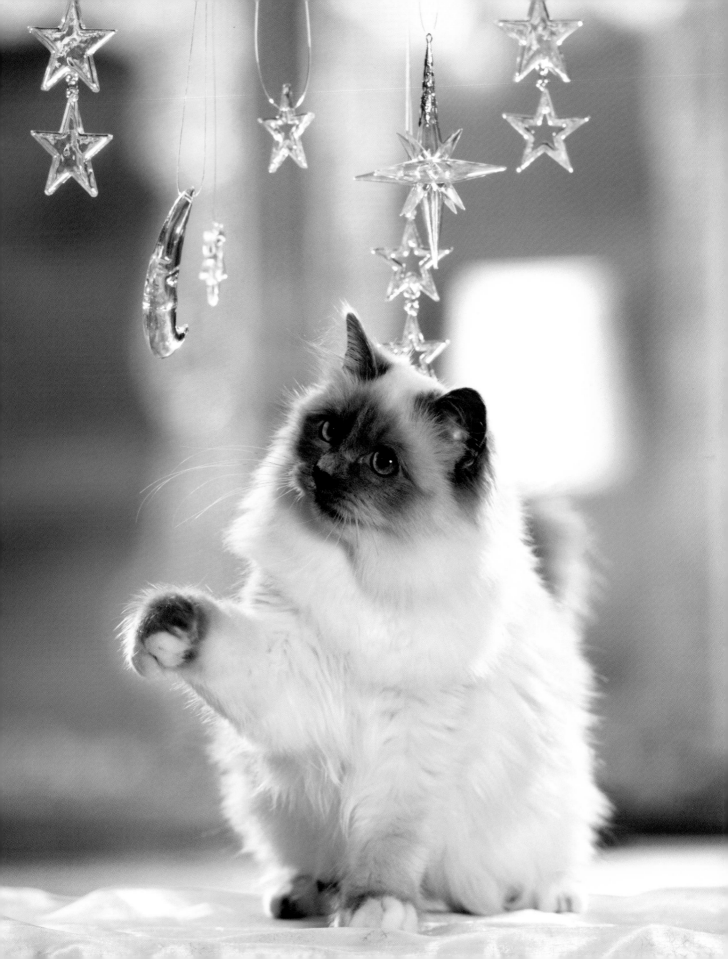

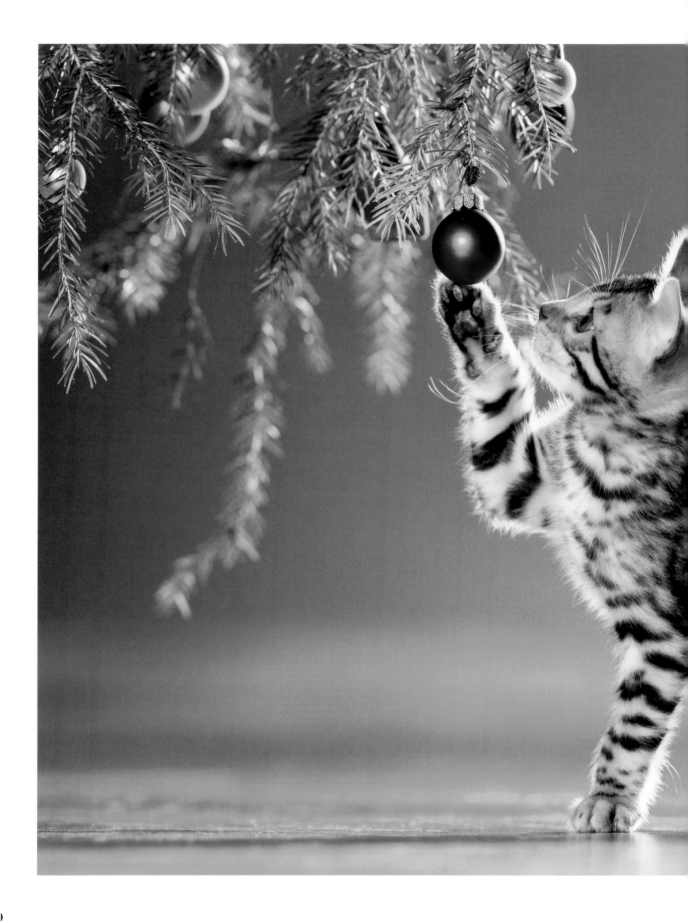

Cat Types

Every Cat Is Really a Puma

One cat lives out her life as a more or less happy plump little puss, far from her original wild nature, yet still basically yearning for her puma-like wild cat nature. The other seizes the first opportunity to tear up your favorite sofa or some other innocent piece of furniture and distribute painful blows to the careless passerby. Yet another breaks out into tender purring and rolls over comfortably onto her back in the tummy stroking position as soon as she sees the beloved can opener. Still another, on seeing any object left lying around or any thoughtlessly placed toes, can't resist starting an orgy of playing and hunting. Just as with people, cats can be sorted into different types and temperaments, and we can find something human, all too human, or something cat-like, all too cat-like. The brief typology of cats in the next few pages can of course do only partial justice to distinctive individual characteristics, but nonetheless some types are recognizable.

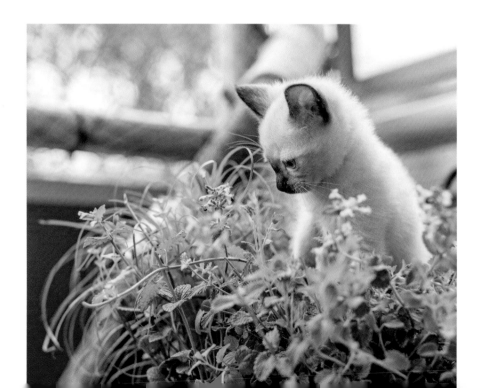

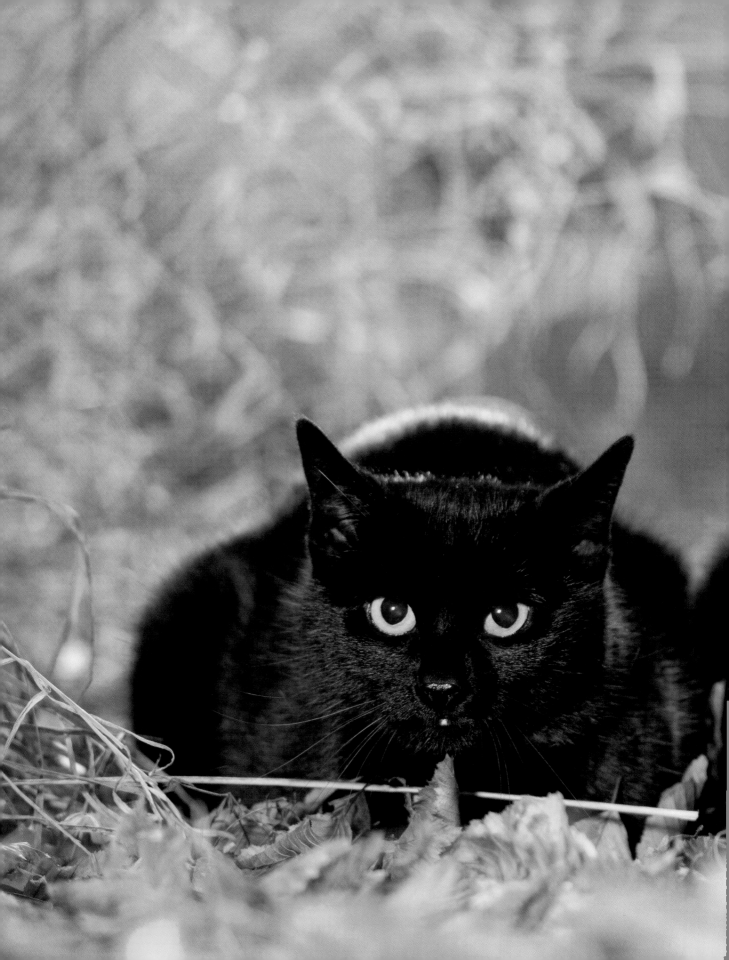

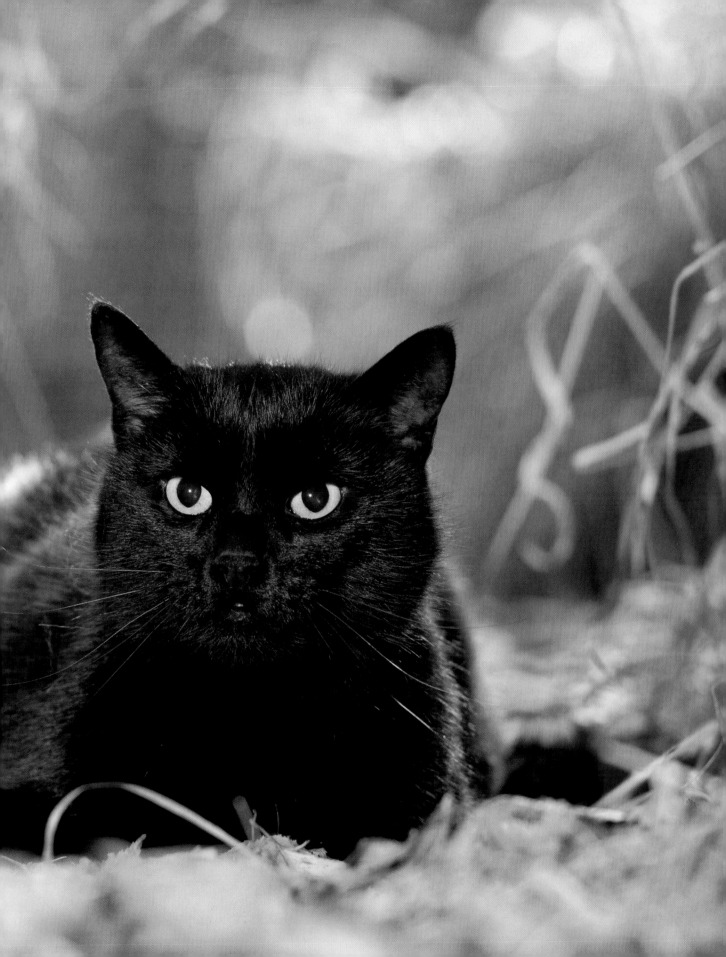

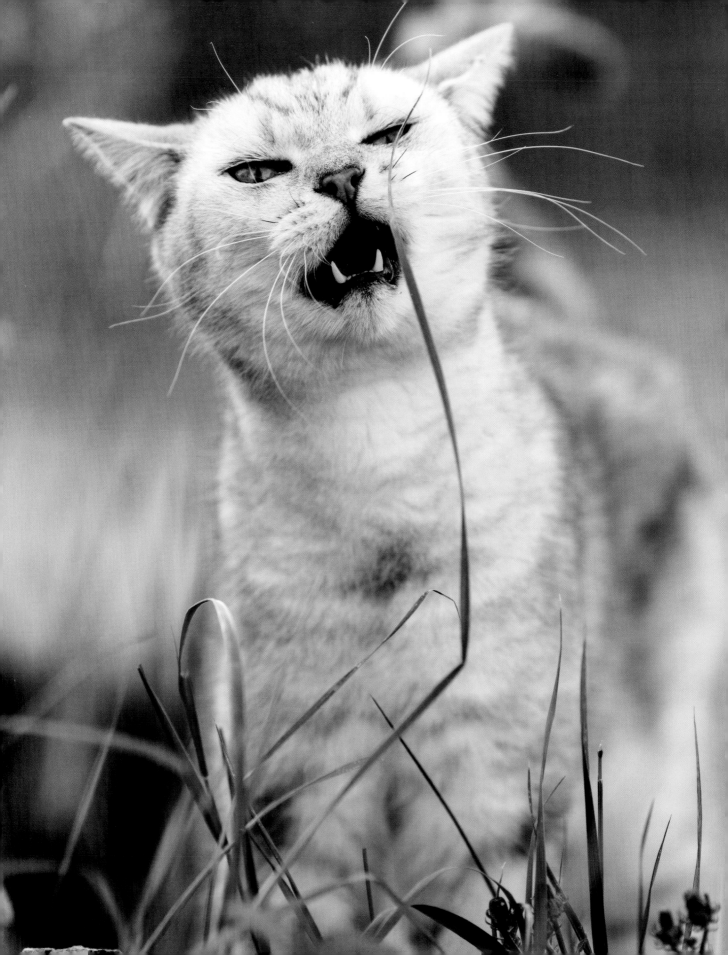

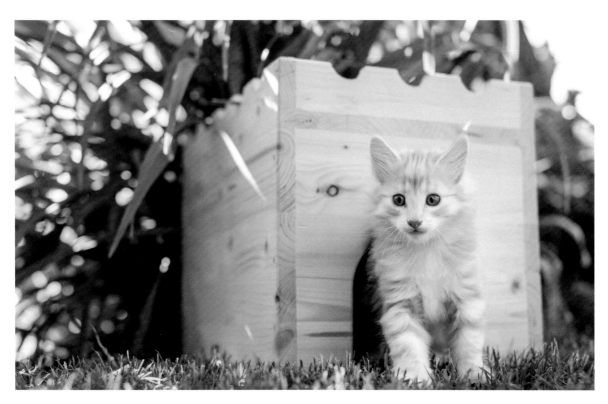

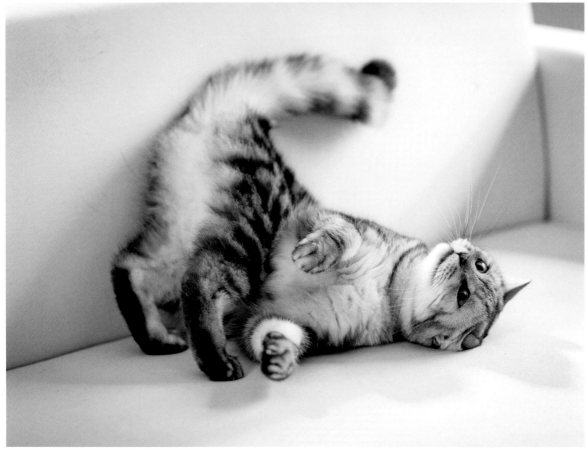

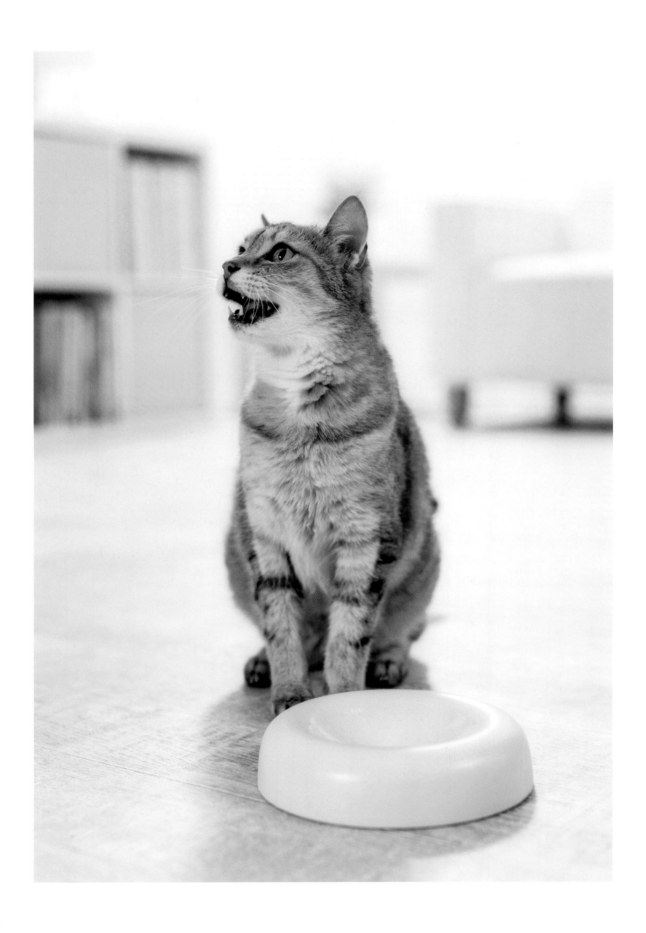

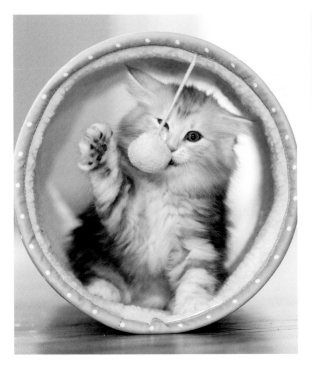
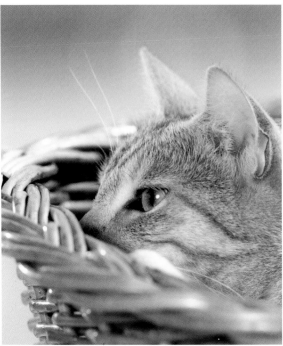
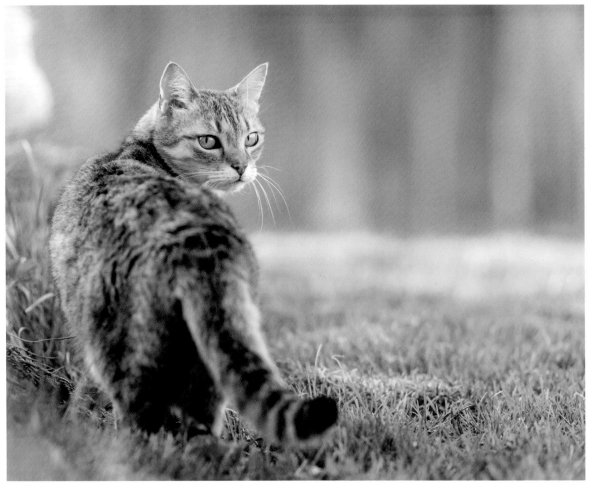

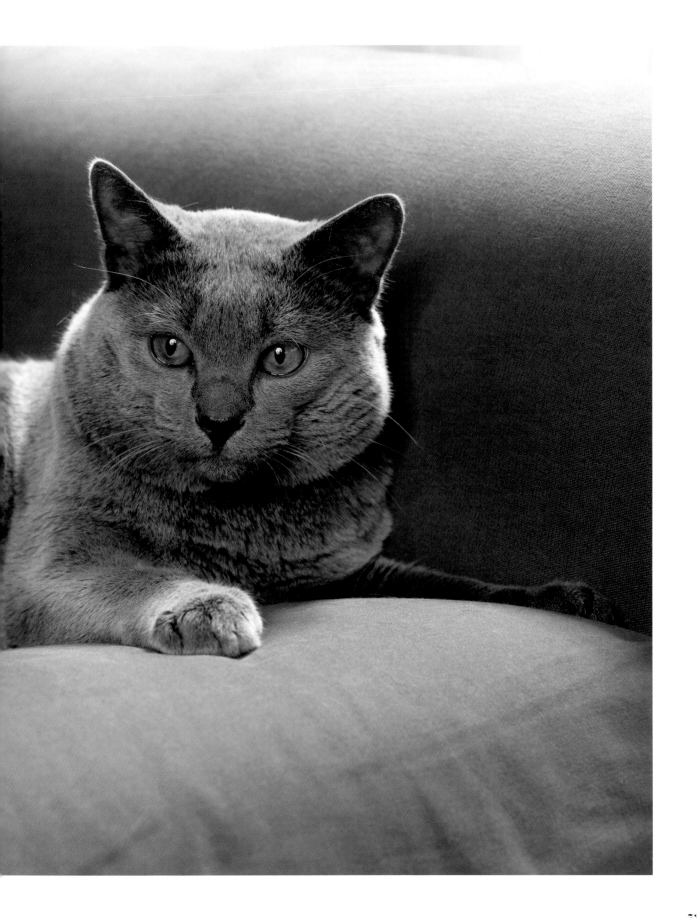

The Gourmand

(or the Fat Cat)

This type of cat can be found among both house cats and outdoor cats. In the world of cat literature this type is represented by Garfield, that cat with so many typically human problems such as dieting, Mondays, and boredom. More than anything, Garfield eats and then rests after eating. Otherwise he is impudent, fat, lazy, and philosophical.

That reminds me of the tale of Toby, the one-time cat of our neighbor, who left one day to seek his fortune and probably now lives, happy and normal-sized, with some older lady who listens to soft music, bakes him shrimp patties, and brushes his fur every evening.

When we met Toby, he was already overweight, with a perceived cat body mass index of approximately seventy-five. Nonetheless he had a graceful walk and was even able to squeeze regularly through our very narrow cat door to take food from our cats' bowls in the kitchen. (He liked only dry food.) He made incredible noises, reminiscent of a snorkeler with breathing problems—not very appetizing. He was able to do this with other neighbors, too, resulting in him growing larger every month and more serious. Naturally this unreserved greed coupled with a lack of style did not make him attractive to me, and the snorting got increasingly on our nerves. Even Thali, our otherwise good-natured playmate, spat at the fat Toby, whom was not much bothered by this and went on eating, snorting the while. →

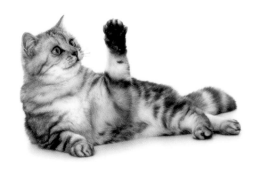

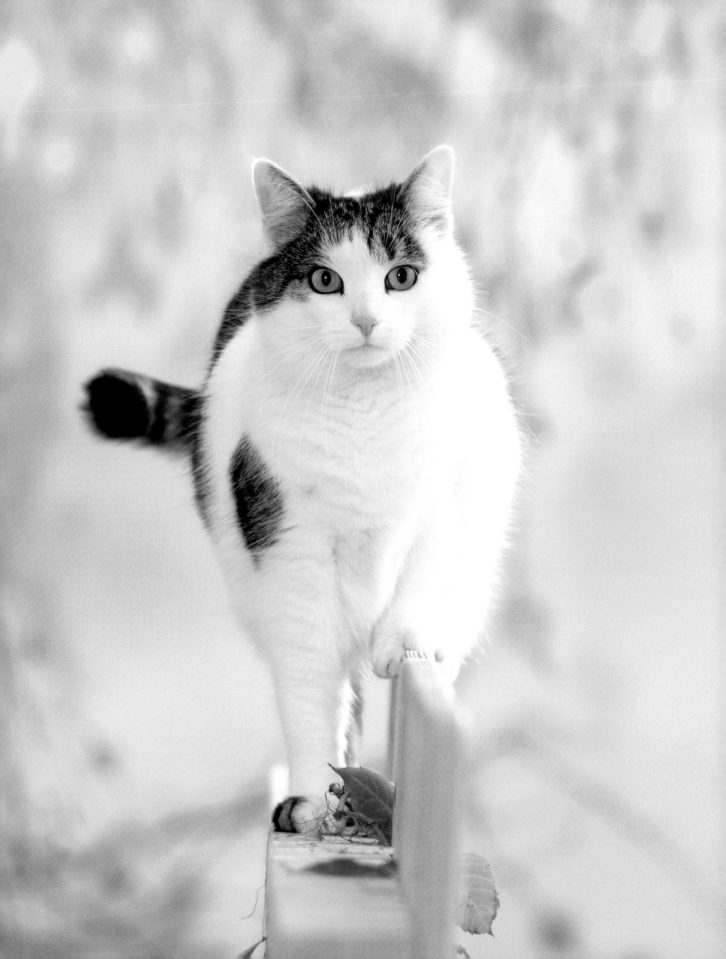

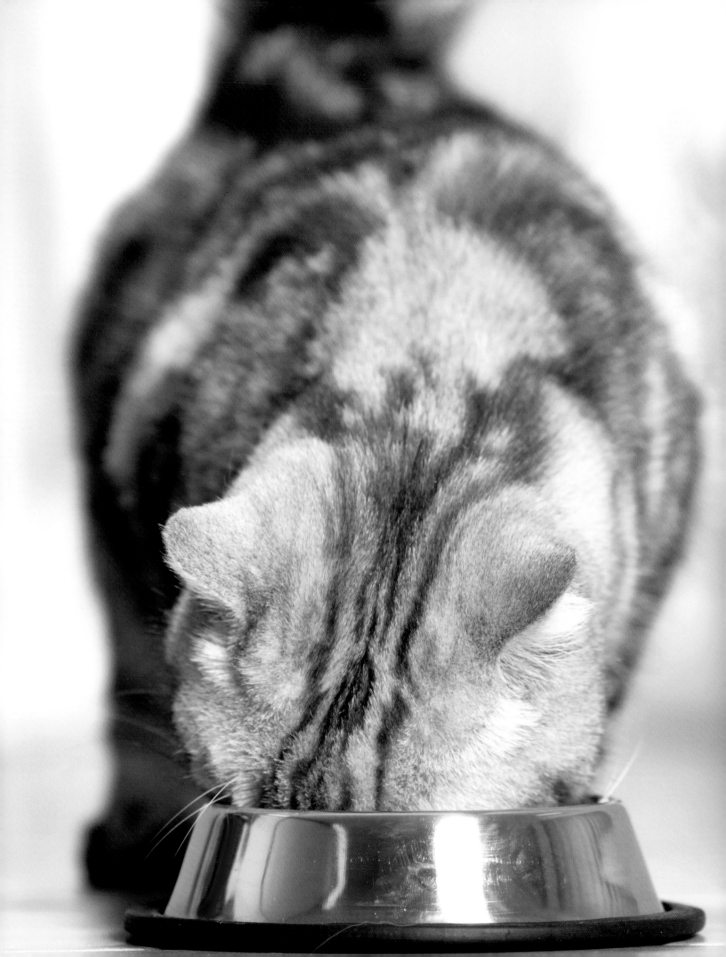

The only member of my family sympathetic to fat Toby was our younger son, who kept pointing out how pitiful he was and how he needed more stroking and did not have a particularly good home life. In our household, so interested in cat psychology, this sensitive observation raised the question of how much Toby's girth was psychosomatic. This idea finally awakened my cat-mother empathy.

The fact was that Toby lived with a clan of six can openers whose members had a tremendous potential for uproar. There were also two silent rabbits for the amusement of the younger members of the family who fell by the wayside in the trauma of noise who were otherwise important. The grown ups were not true can openers, for Toby only got food from a bag. Nonetheless the cat was eventually so fat that he couldn't even clean himself properly. His mistress rose to the occasion by energetically shaving the matted spots, making him look undignified and leading to partial sunburn in the summer.

Toby's stressful drama finally escalated when the family decided to get a child-loving dog. This suited them very well, as it increased the potential for uproar. The dog lived in the hallway and prevented the cat from getting into his cat den following the motto, "It would be good for the fatso to spend a night out and do a bit of hunting."

Whenever there are stories about child neglect and abuse the demand for parenting standards through licensing comes up, as proof so to speak of a basic knowledge of raising a child. I sometimes think that a type of license for raising cats or even dogs would be similarly desirable. →

Cat psychologists know that a fat cat is generally not a happy cat, for plumpness is contrary to a cat's nature. Among wild cats—and that includes the big cats—there are no fatties whose stomach hangs practically to the ground. When they are physically and spiritually healthy cats have a natural brake for eating. They eat only as much as they actually need.

Here's how to determine more or less if a cat is too fat: if you look down on her back there should be the suggestion of a waist, but not when she is sitting down. Otherwise the cat is too plump. You can also find out about the prescribed weight of a cat according to her type or where the mixture of types is known. The size, race, and bodily structure must be taken into account. For instance, a British shorthair has a different ideal weight from a Siamese cat. (Yes, oh love of my life—Sookie is not too fat; it is just her fur.)

There are many reasons why a cat may become too fat. She may be lonely, she may be bored, or, as a kitten, she may be inappropriately fed. Or she may wander, have broken bones, or have learned bad eating habits from her owners. But it is just sad when a fat cat can no longer lead a proper cat life. Every cat is naturally built perfectly, with a muscular and strong body. They may look as though they lie around all day dosing, but cats are mobile; they go hunting, inspect their territory, and, if they are house cats, love to play all the time.

One day, when the racket and howling got to be to much for him, Toby must have remembered his cat nature. At least that is what we imagined. He then packed up his cat belongings and left, his stomach waving solemnly back and forth. In our minds he is now living with this charming old lady and lies evenings before the fire while she sorts apples, or something of the sort. Anyway, he is happy now. 🐾

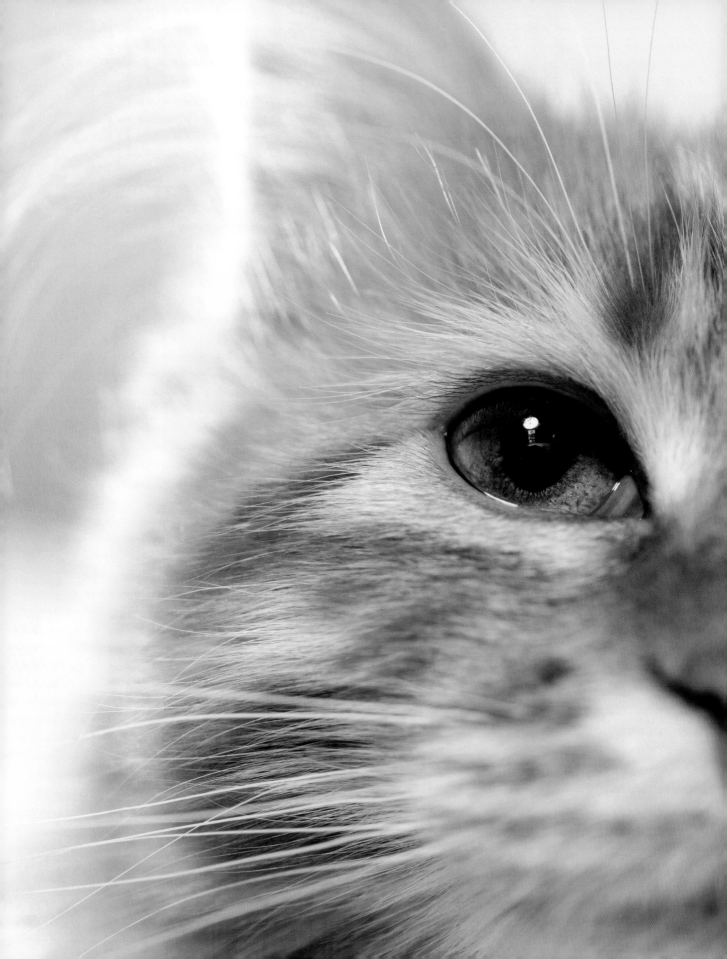

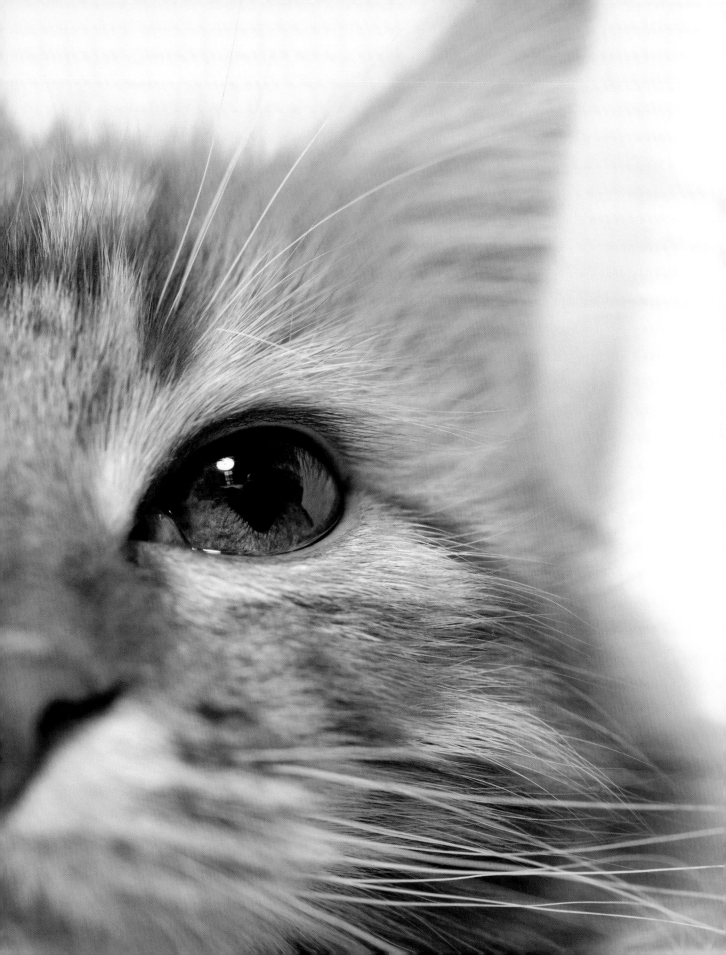

The Wanderer

(or the Adventurer)

As children we loved the Walt Disney cartoons. One of our favorites was *Aristocats*, which we watched passionately one hundred and fifty-five times. My children, too, got to know the enchanting Duchess with her charming children and the handsome Thomas O'Malley, who helped the aristocratic little cat family escape the deadly intrigues of the butler Edgar and find its way back to Paris and the villa of the elderly opera diva Madame Adelaide. If I had had daughters, this film would have impressed upon them a devastating picture of men, if a thrilling and entertaining one.

Thomas O'Malley—his full name is Abraham de Lacey Giuseppe Casey Thomas O'Malley—is the classic wanderer. He can sing beautifully, flirt even better, and has exciting friends in the form of an anarchist jazz combo and a fashionable if somewhat decrepit penthouse in Paris. He sang the classic, "Everybody Wants to be a Cat" with his friend Scat Cat who was originally written to be voiced by Louis Armstrong and named Satchmo Cat.

The orange-colored cat with the gentle male voice, that probably seduced more than just one lady cat, possessed that unconquerable cunning found only in creatures who truly know how to value and to enjoy their liberty. Thus he wanders through the world without rules or relationships. →

This changes when he first sees the pure white noble Angora Duchess, who because of certain circumstances in which the brave dogs Napoleon and Lafayette play a role in, is stranded in the countryside. O'Malley promptly falls in love with her, flirts, serenades her, and clearly looks forward to an exquisite adventure. He is in for a shock, because he discovers that the adored one comes with a whole stallfull of children: Marie, Toulouse, and Berlioz, all charming and musically gifted. Essentially a scene from true life, which every single mother with a certain attraction to untamed males might recognize.

The story runs its course. Of course he embraces the children with his big, big heart, and on the way home he gets to be like a father to them. Along with his musical pals, he shows in the furious finale truly heroic qualities, defending woman and children with teeth and claws. In gratitude Madame Adelaide adopts him. He finds a place on the side of his beloved and finally wears a white collar and is domesticated, well tended by his barber. (We don't know how to take this.)

This type of cat is often to be found in real life as well. In my family he is called Tiger and belongs to my cat-crazy neighbor A. Tiger used to be called Merlin. He decided to move in with a clairvoyant, but chose not to leave his beat the next time she moved. (She moved frequently.) He then went through a process of domestication.

A.'s daughter spoiled him by getting him accustomed to regular and clearly addictive brushing of his coat, and A. bought him special food for his teeth and took care that the door to the terrace could always swing back and forth. Since then he only goes around the house.

Researchers of animal behavior know that the wanderer in some ways represents the archetypical cat: a highly specialized hunter who spends a lot of time investigating his surroundings. The wanderer enjoys his street life and feels well only when he can go outside regularly. If the door is kept closed he mutates into a dissatisfied and tormented soul and becomes dirty and unhappy. As Barbara Schoening of the Association for Animal Behavioral Medicine and Therapy in Hamburg says, "You cannot turn a wanderer into a house cat." Peaceful coexistence can only succeed with the motto, "Live and let live." 🐾

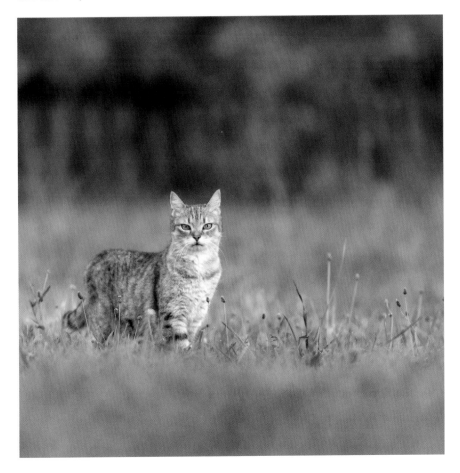

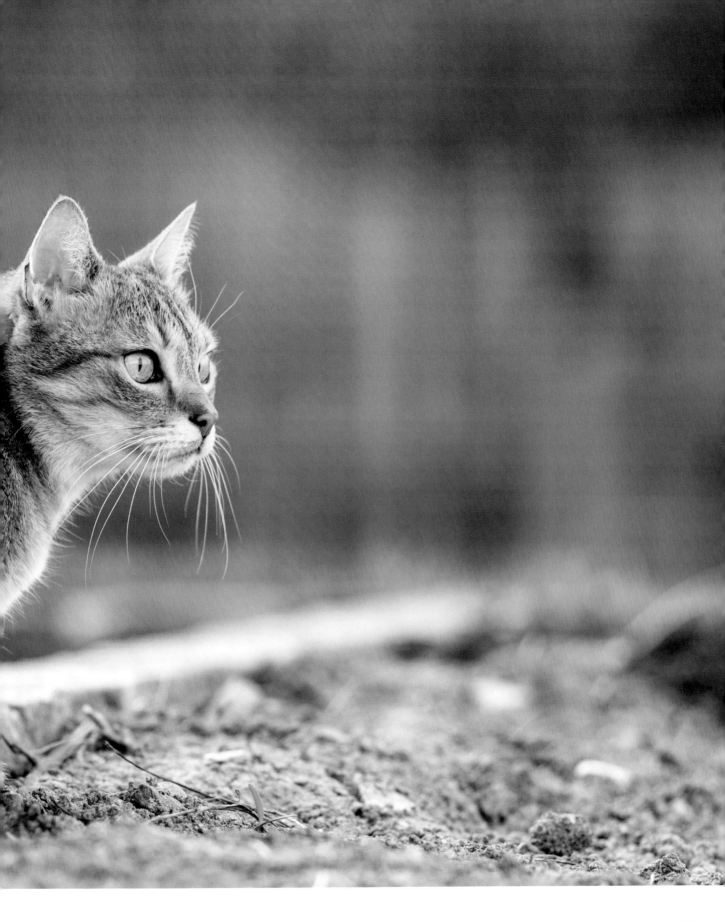

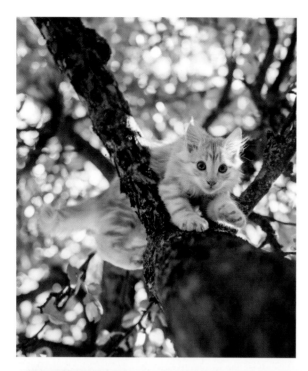

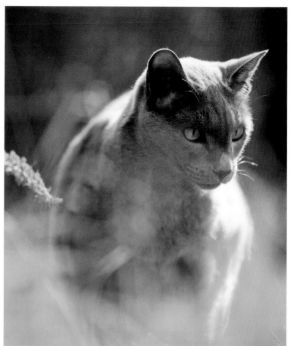

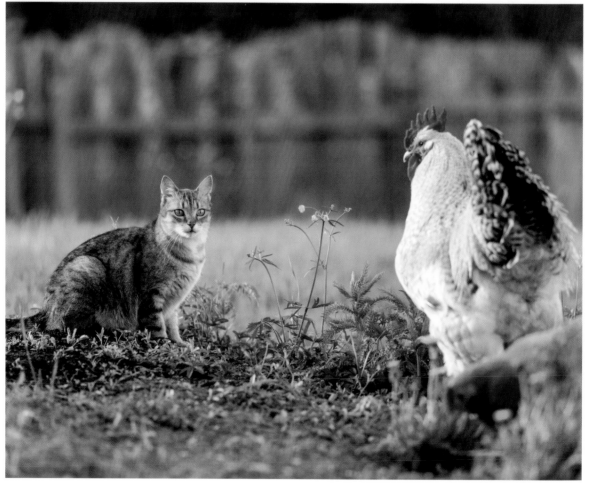

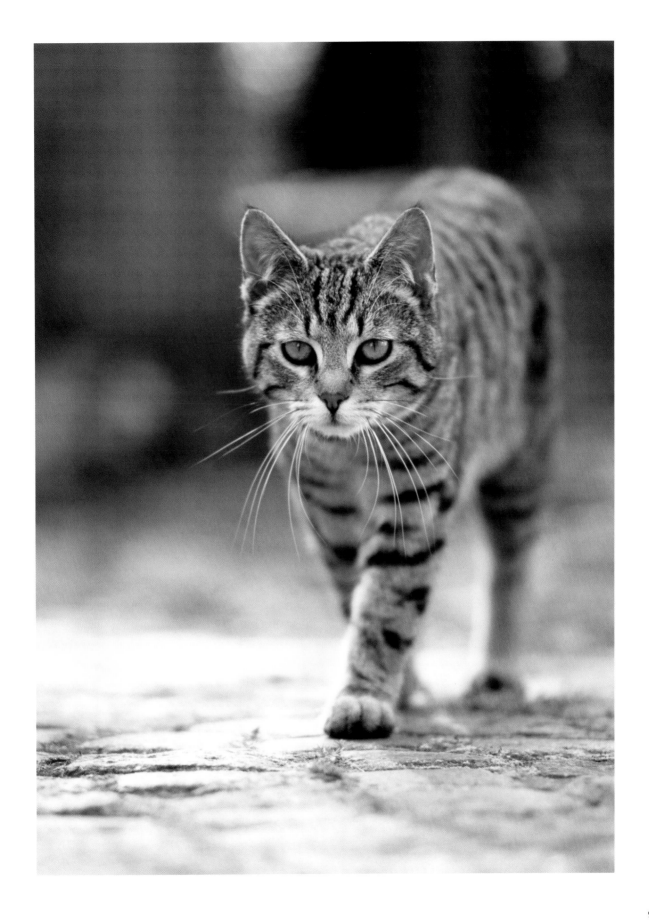

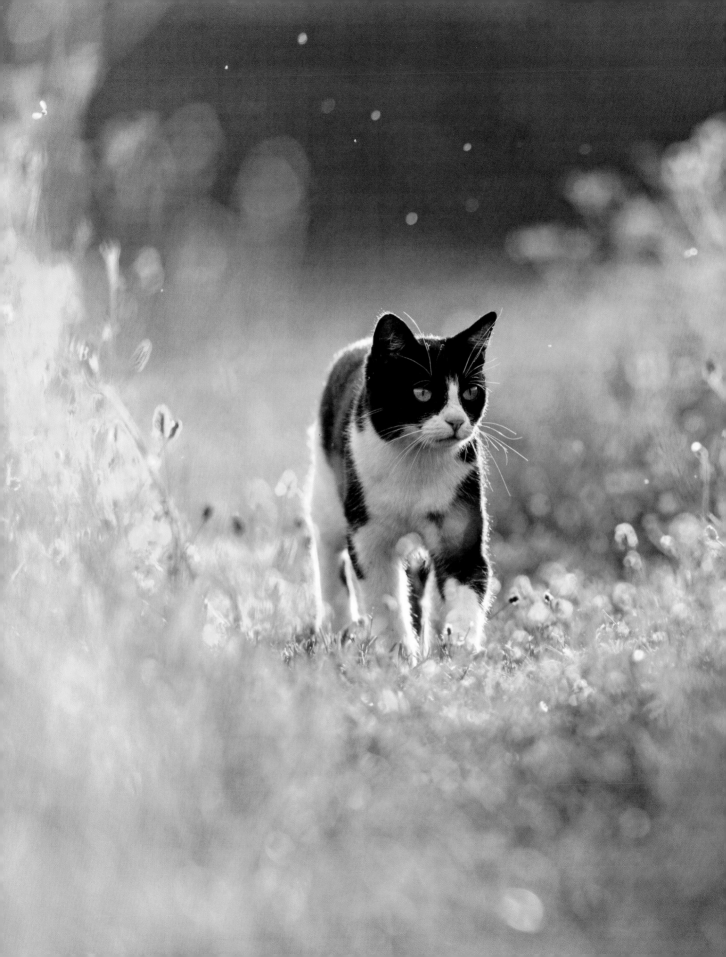

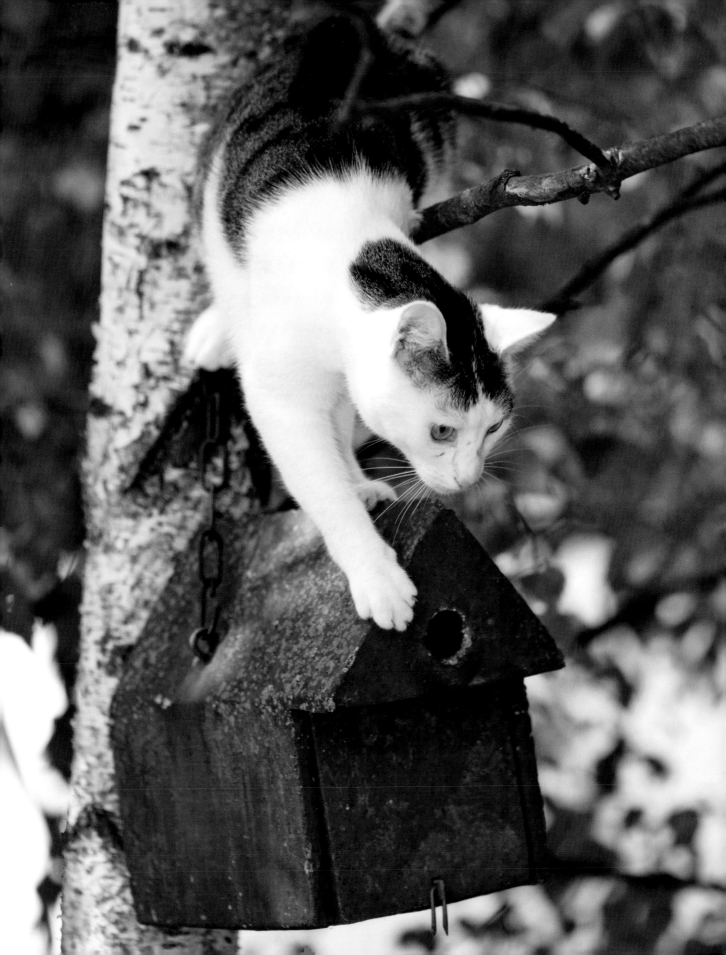

The Rat Teaser

(or the Killer)

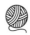

This type of cat is a subtype of the wanderer. A fitting literary equivalent can be found in T. S. Eliot's wonderful burlesque book of poems, *Old Possum's Book of Practical Cats*, the basis of Andrew Lloyd Webber's musical, *Cats*. Mungojerrie and Rumpelteazer are a sort of rowdy combo, famous and on every tongue. They were infamous, notorious. "They made their home in Victoria Grove—that was merely their center of operation." Their true business, true field of operations was as vagabonds in the courtyard. They were known to everyone "in Cornwall Gardens, Launceston Place, and Kensington Square." (See *Old Possum's Book of Practical Cats*, New York, Harcourt Brace and Co.)

Ours is a classic can-opener family, with a magical attraction to rat teasers. Our first cat, Luis Figo, named after the then Portuguese national player, was a great rat teaser with a tendency to spontaneous rat hunting. Perhaps the act of killing was simply too banal. Like the player he was named for he was a sort of artist, fond of bringing live mice into the house and letting them live with us for a while until he finished them off or they disappeared during the night. The can opener often went ahead and set traps with little bits of cheese or ham. The peculiarity was that the next morning the tidbits were gone but the trap was empty. →

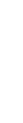

Unforgettable were the three days when a white rat with black spots moved into our kitchen. We called him Ottokar. He caused a certain irritability in the adult can openers, accompanied by loud threats: "If he does that again, he'll be thrown out!" It must be added that the man of my heart was very fond of Figo in his youth and even rescued him in a terrible snowstorm, but everything has its limits.

Ottokar, too, disappeared one fine day after a final wild chase in which he and Figo succeeded in knocking over a part of the same man's collection of red wine, lovingly laid down in a rack in the cellar. When cleaning weeks later, we found signs of Ottokar's brief stay in the kitchen drawer and even spoke of him sentimentally from time to time, not without stressing his pretty coat. Days after he left, a friend sighted him on the terrace, where her two little ones were charmed by the amusing animal. My friend, who had recently considered becoming a cat mother, too, spontaneously dropped this idea and turned to keeping rabbits.

Figo's successor Maya was also an enthusiastic rat teaser, but she usually made short work of mice, rats, blackbirds, and company (see the fatal bite, p. 16). Her favorite hunting technique was legendary; she would lie under our neighbor's birdhouse and wait to see if a bird flew into her mouth. But perhaps that was only a sovereign gesture of "Just wait a bit and I'll get all of you."

Meanwhile Sookie has taken over the role of rat teaser, and it continues to astonish us that such a pretty, gentle creature could develop such bloodthirsty killer qualities. She reminds us somewhat of Nikita in Luc Besson's film after she had completed her course in killing: elegant, beautiful, and absolutely deadly. Sookie loves to play with her offerings before she does them in and with a few bites devours them. Memorable was the night when the final chase took place under the bed of her chief adult slave, interrupted by shrieks from said slave and constant turning on and off of the lights, which extended the length of the death ritual and the following consumption of the bounty. As a result the can-opening slave had deep rings under her eyes and was in a bad mood the next day. The little one doesn't draw the line when it comes to her favorite young can opener. She once placed a live mouse under his quilt.

Thali, who has yet to have mastered the fatal bite, tries to ignore all this activity. His variation of rat teasing is jumping over the fence into the garden with a clearly feeble old mouse in his mouth and receiving the spontaneous praise, "Good for you! You caught a mouse!" In order to explain how he did it he lets the animal fall out of his mouth, looks puzzled as it disappears into the bushes, and gives a quiet plaintive meow. Clearly, a cat must be born a rat teaser. ☙

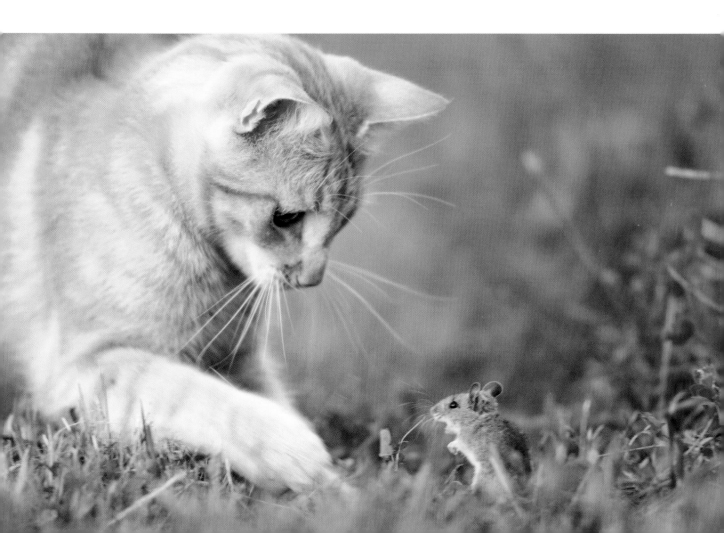

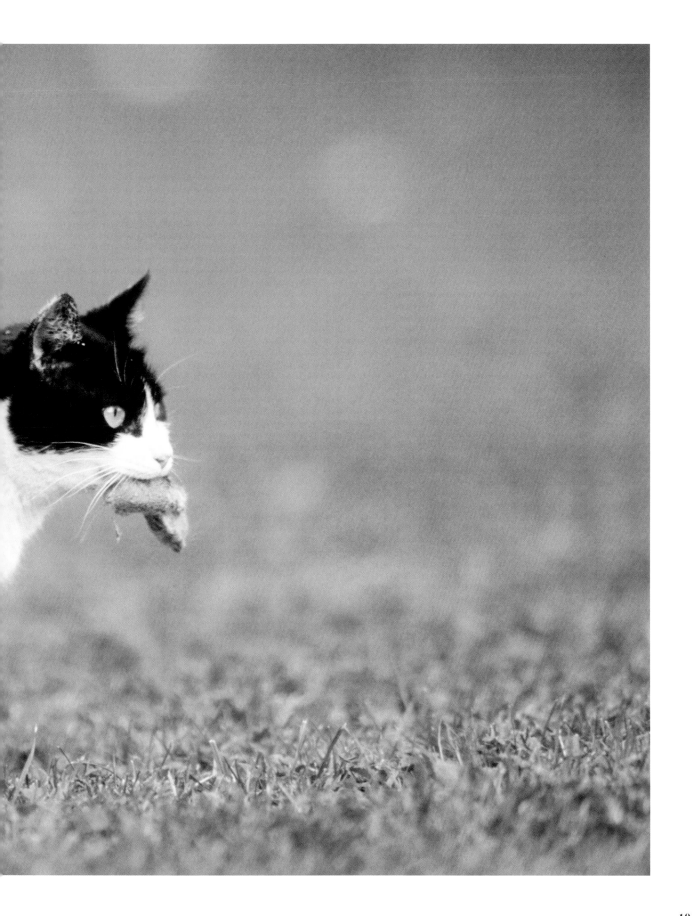

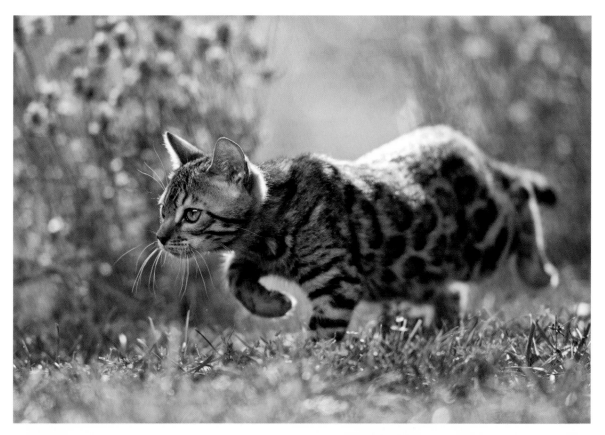

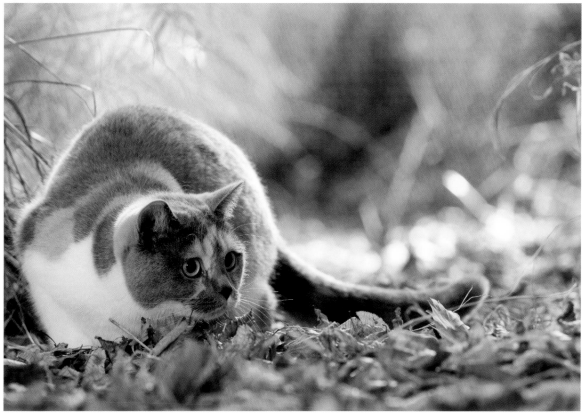

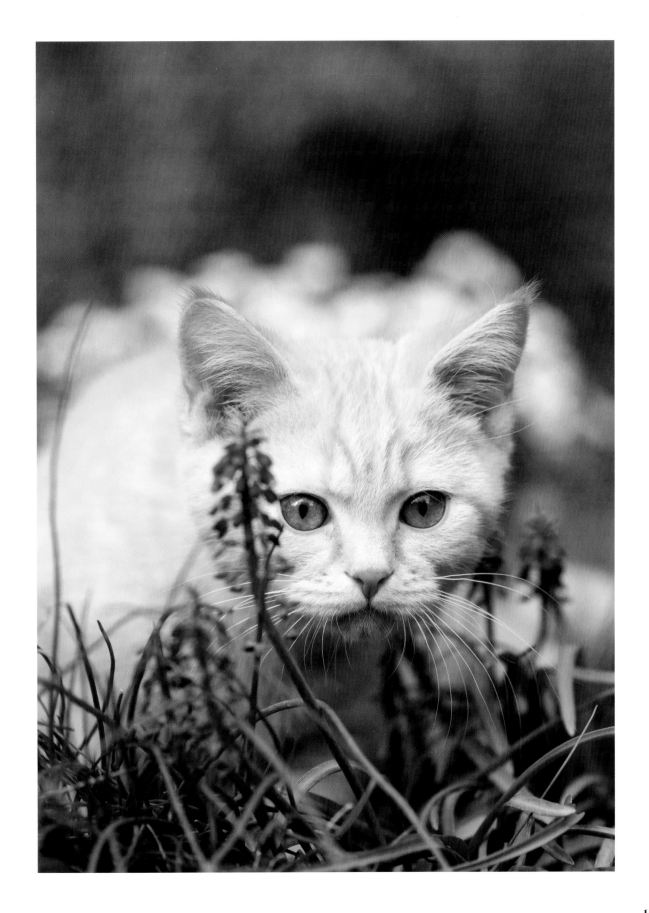

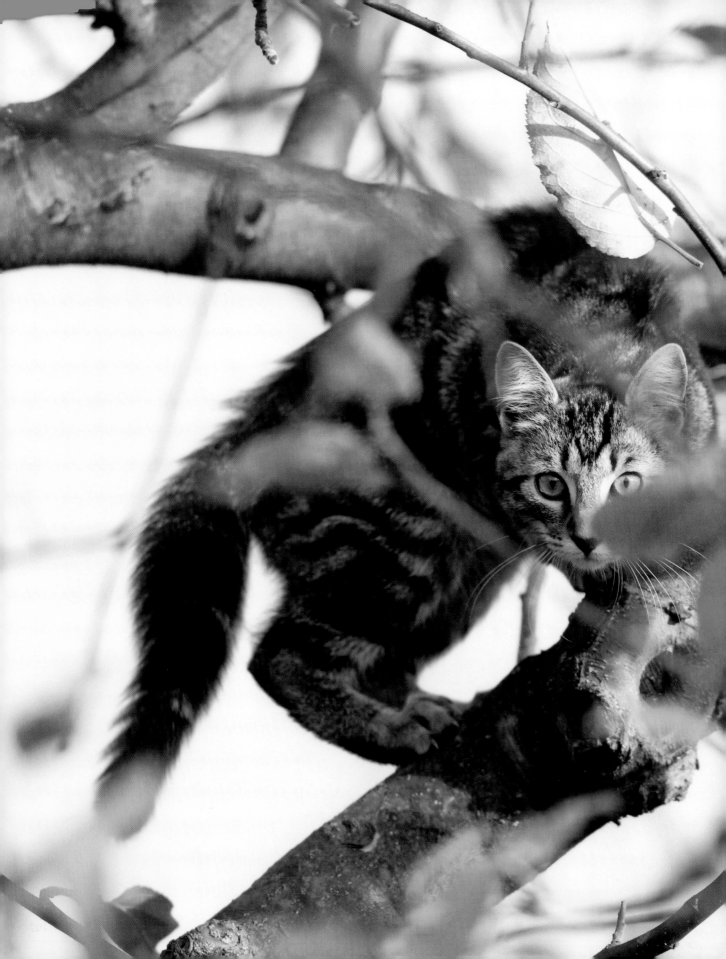

The Playful Cat

(or the Sweetheart)

In fact, the playful cat is not a unique type, for every cat must play to feel well. First they romp with their siblings. That is how they all learn the skills they need to catch their prey, fight, and turn quickly when things get tight. While kittens in playing exercise their social skills (who should I jump on first, my little brother or my little sister? Oh, I'll jump on both!), adult house tigers use play as a sort of workout. Cat psychologists know that cats who play are emotionally better balanced and, no wonder, fitter than couch potatoes. Cats who don't play are often exhausting, meowing constantly, always discontent, and courting attention. In any case nothing is as good a source of entertainment as a cat at play.

While young cats like to play with anything that moves, rattles, and sways under their nose, grownup cats love one thing passionately: playing with prey. When in doubt, the prey may be the tablecloth or a curtain—the main thing is that it moves. They also love running an obstacle course through the living room or kitchen; they can develop incredible creativity. →

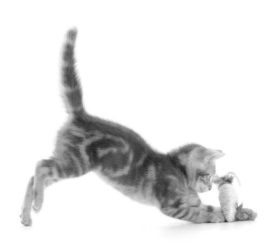

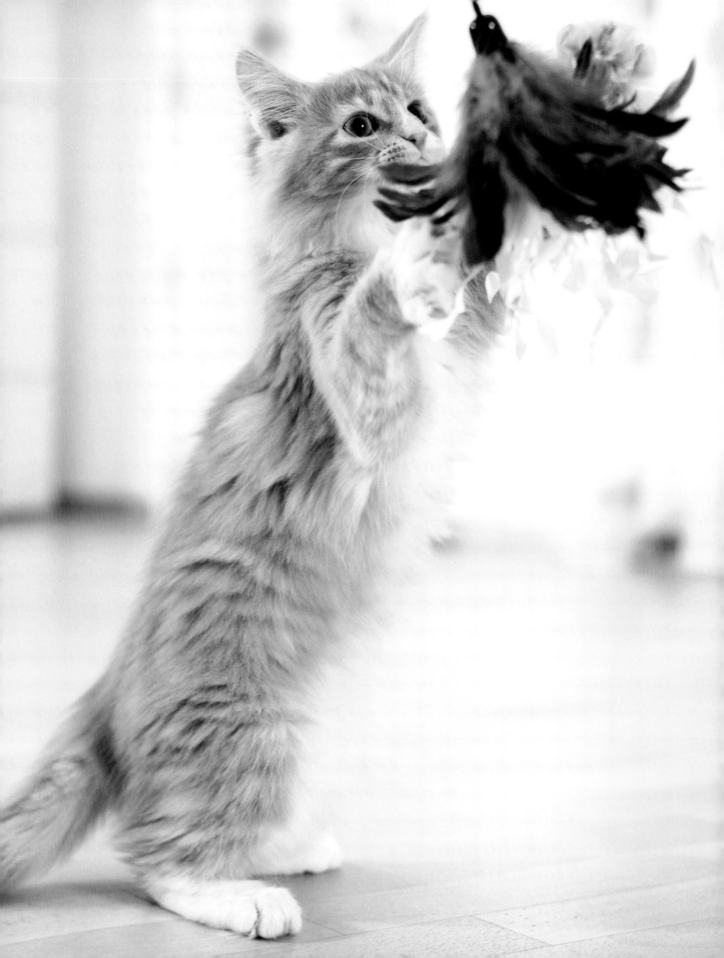

They exaggerate so greatly in this game that anyone who participates or watches holds his sides with laughter. Thali, for example, races as though possessed through the kitchen into the living room, over chairs and tables, comes to a full stop in front of the terrace door, twirls around wildly but quite acrobatically behind the armchair, and comes back. As the official director of cat play in our household he has further developed the game of capturing toes, which all our cats have mastered. This is highly successful when the can opener is asleep and has thoughtlessly let the cat into the bedroom. If he moves his feet in his sleep, he becomes wide awake and complains loudly, as a cat has sunk her claws into his toes. The toes game is also effective when the cat hides under a step and someone comes downstairs without paying attention. This variant can, however, become dangerous for both parties (falls, accidental stepping on parts of the cat, loud hissing, and so forth).

Toy mice are also terrific. Some rustle or can be wound up—most entertaining! But they do require proper service on the part of the can opener. You can have a lot of fun with your cat and look at her "play face." That's what you call it when she suddenly ducks, lays her ears to the side, and opens her eyes wide: "You can see I'm really dangerous, right?" And every playful cat is a great actor and can switch rapidly between the role of the attacker and the persecuted innocent. Thali has refined playing with mice by seizing his sister's dead prey and then tossing it around the place for a while. This is hardly elegant, but is somehow a special circus act because it is done with great seriousness. The fact is, if you need a little break, playing with the cat will help. It brings the world back into balance relatively quickly and has a wonderful calming effect in a wonderful, catly way. 🐾

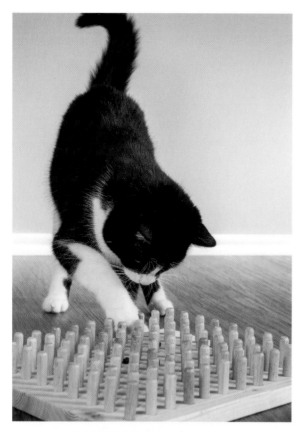

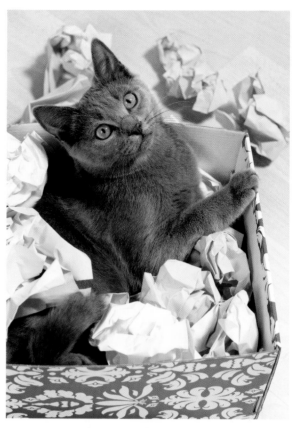

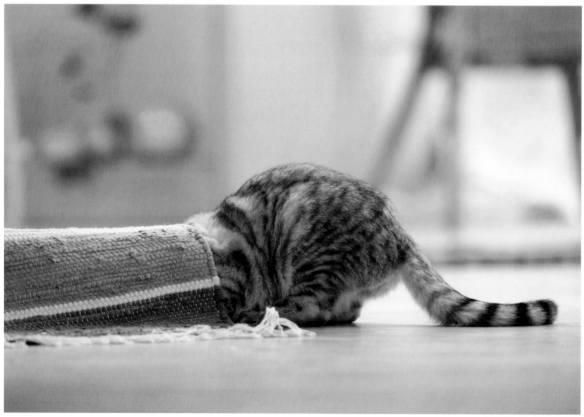

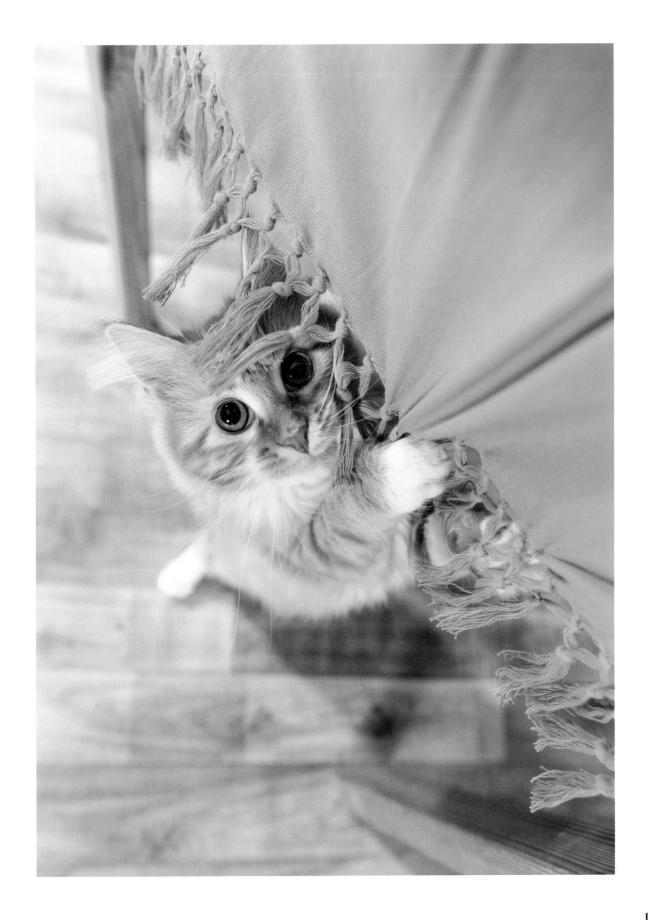

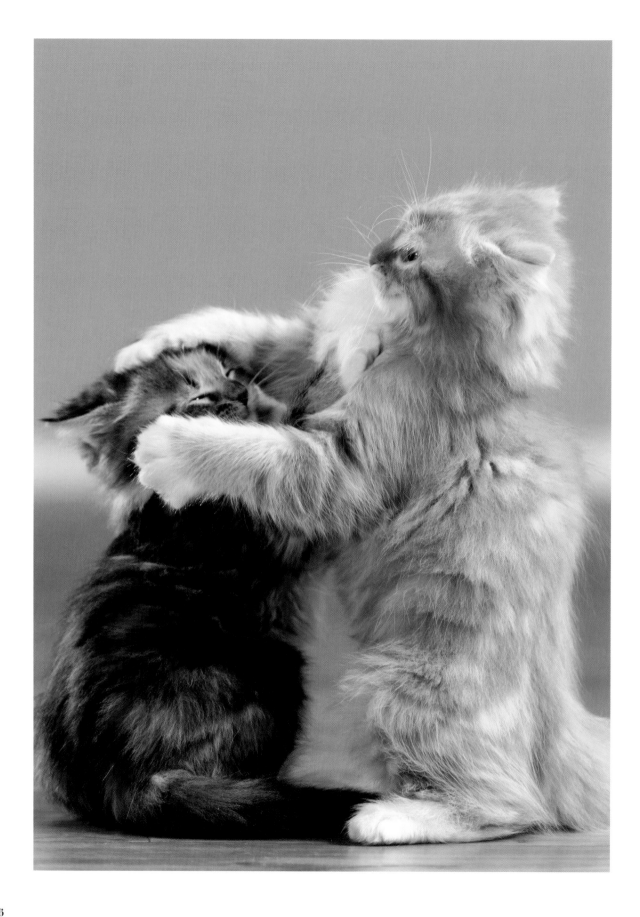

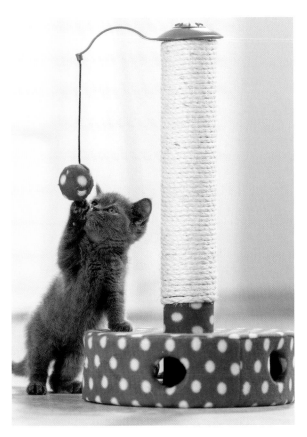

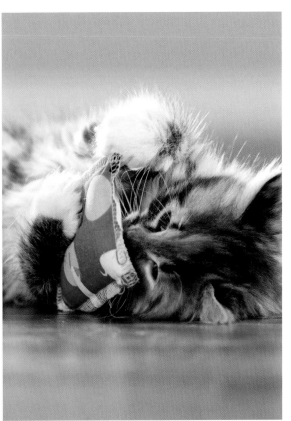

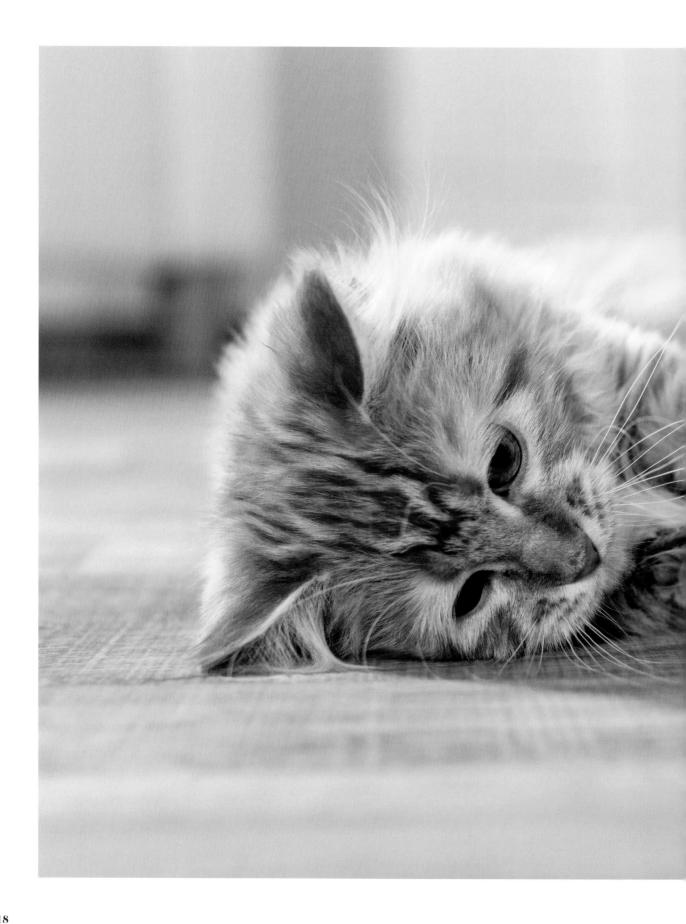

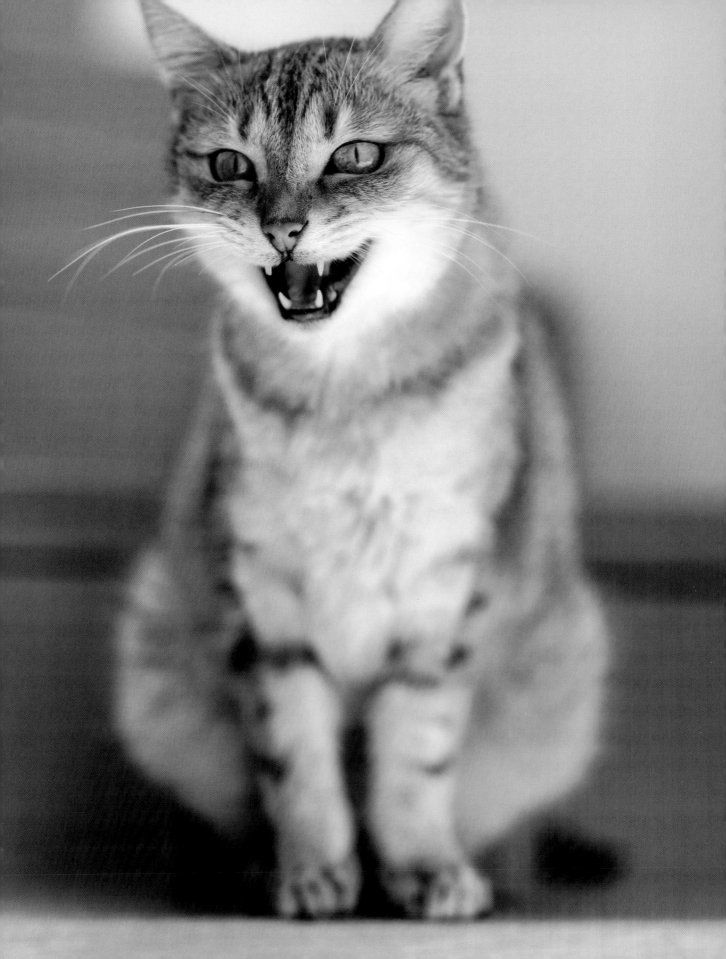

The Diva

(or the Princess)

When you think of this cat type, you shouldn't imagine Greta Garbo, Andy Warhol, or Madonna in the form of a cat. Cat divas typically display as arrogance a misunderstood inapproachability or a particular sort of sensitivity or have eccentrically grand airs towards people. The very name diva suggests something divine, but also something fragile and disagreeable, sometimes even something of genius.

Enter Topsy, not exactly a name for a diva but due to her uncertain origin and the wealth of ideas of deserving employees in an animal shelter. Together with her brother Domino she moved in with my friend E. and her three sons, who were in desperate need of some cheering up after a separation. And since they saw how our good cat spirits (usually) made our life much nicer, they came up with the splendid idea of taking in two orphan cats.

You should not assume that animals will be eternally grateful because you have rescued them from a terrible fate: starvation, neglect, or ending up with awful people. An expectation of the sort, "We rescued you, therefore make us happy," is unproductive for both people and cats. A particular situation arises when the cat whom you have magnanimously taken in turns out to be a diva. There is less potential for comforting from such a princess, but a greater chance of daily excitement. →

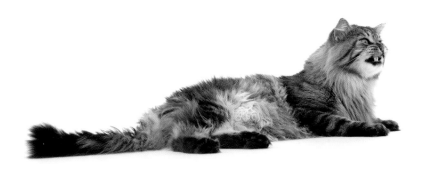

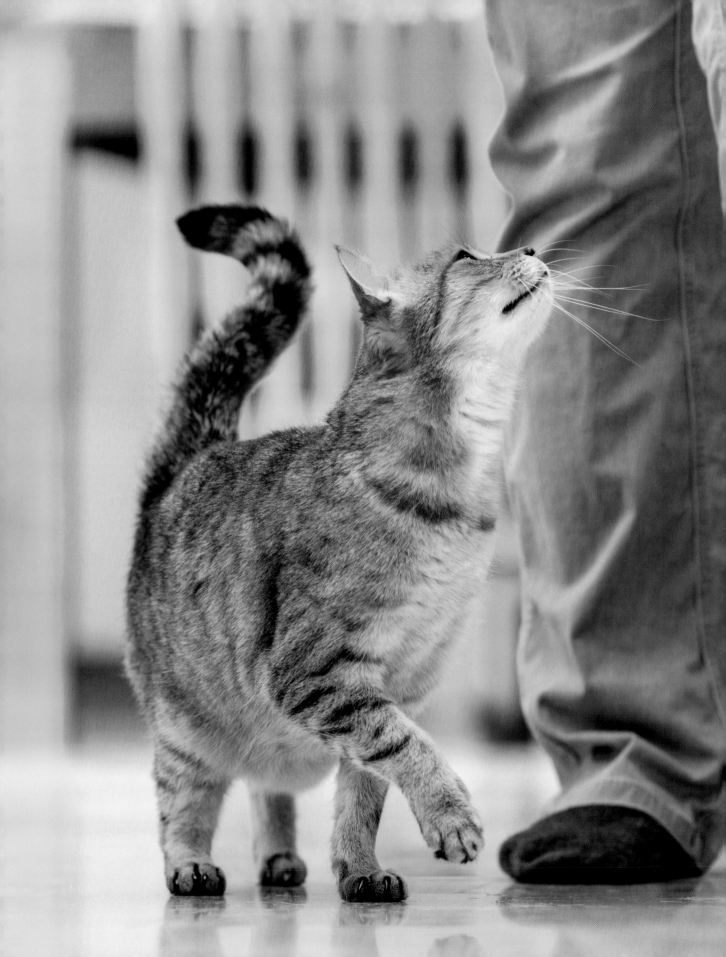

When cats move in with you, they take over the quarters and the apartment or house. They then do what they want, and the can opener can deal with it. Best is when the people comply and open their home so that the cat can makes itself at ease everywhere. If you yourself are particular about your haven, living with a cat is not so well advised.

Relations between cat and person can vary from the highest possible regard (just as you may feel towards an utterly loveable person you hold to be mentally not quite normal), a neutral stance (clear separation between the lord and master and the can opener, cat box cleaner, and provider of the scratching post), to rejection. In that case that cat will usually pack up her goods and look for a new home.

From the very start, there was a big difference between Topsy and Domino, the two newcomers in E.'s house. Domino quickly showed himself to be a cuddly and completely well-meaning and tolerant companion who allowed himself to be carried about by E.'s younger son in orthopedically questionable positions as long as he was properly stroked afterward. But Topsy was, well, difficult.

Domino's sister is the exact opposite of the jovial and snugly Domino, who will good-naturedly forgive any sort of bad behavior. Topsy is shy, dislikes any excitement and noisy people and reacts with extreme sensitivity to any small changes in her can-opening personnel—a princess and a pea. This quickly became apparent at her sons' rowdy birthdays and when E. dared to introduce a new lover who was unsuitable in the eyes of the cat. In both cases Topsy displayed her indignation over the uninvited intruder into her home by peeing on his bed. As cat pros know, that smells very unpleasant and is not easily removed from textiles. →

Now behavior of this kind is not always to be attributed to diva cats. The cat psychologist Katja Ruessel writes, "From Kitty's standpoint, a new partner coming into our life causes as much turmoil as the birth of a baby." But it may also be true that the diva cat has an unusual sensitivity to a person's tolerance of cats and expresses herself accordingly.

A diva always makes clear what she finds comfortable and what she can't and won't stand. This may include wild children, a baby, a new husband or wife, or a new scratching post—not to mention new cat food. The strictest cat divas are those who completely ignore their can openers if they make some sort of mistake. What you must never do with a diva is run along behind her, and not only to preserve your remaining dignity. Cats are too clever to tolerate such belittling behavior. By the way, this also holds when a diva won't eat various foods. The cat psychologist lays down firm rules of behavior for weak-willed and inconsistent can openers: Offer freely accessible food only at specific times. However, under no circumstances should the cat go too long without food.

At present there is no known desensitivation training program against loud people or unloved new lovers. You can try supplying the newcomer with bribes (tuna fish, cat milk) or, as Katja Ruessel writes, "You can also play the pre-recorded voice of the partner softly while offering the cat tasty delicacies." Meanwhile, if the cat proves to have an unshakeable instinct and the newcomer turns out to be an idiot, thank your cat and buy a new mattress. ❧

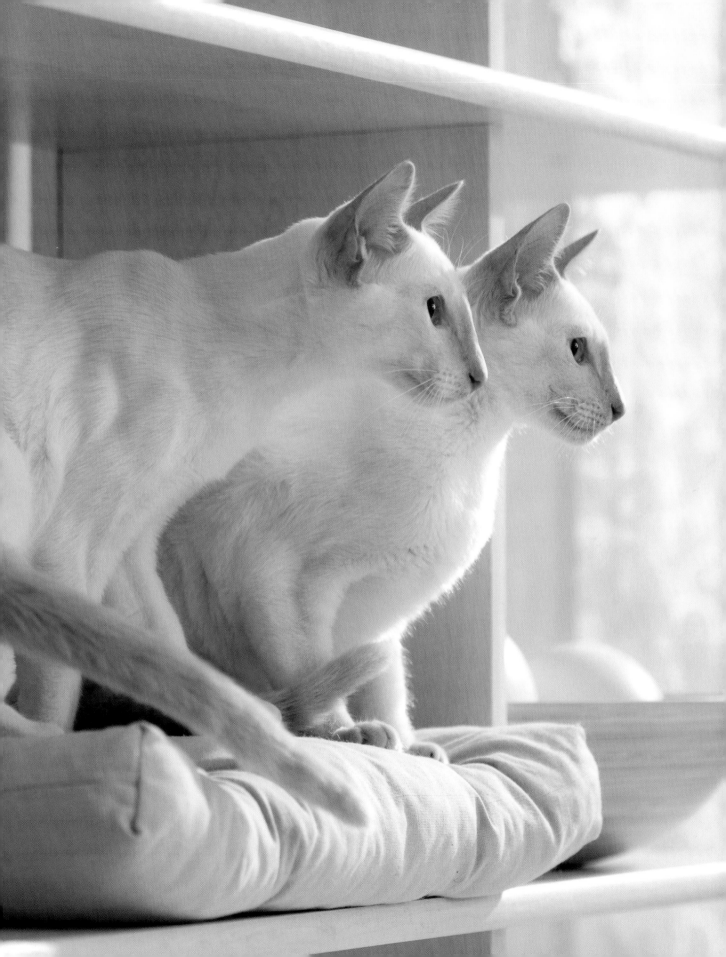

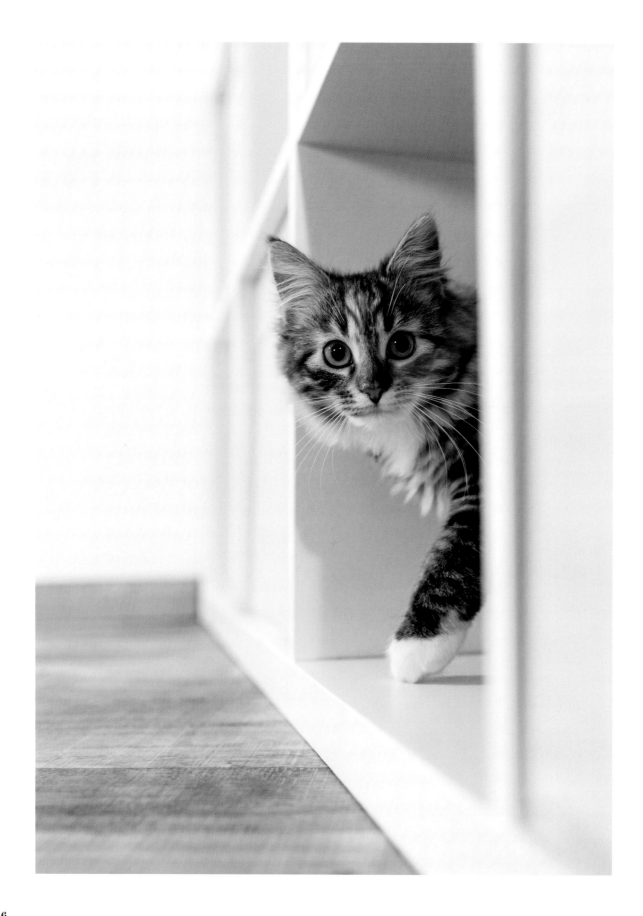

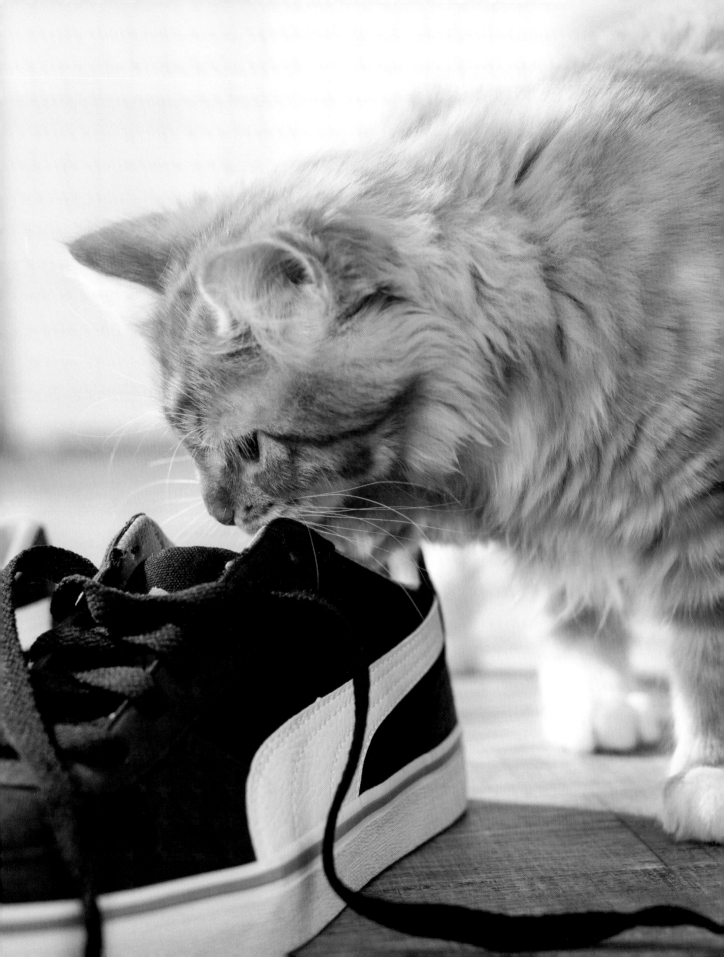

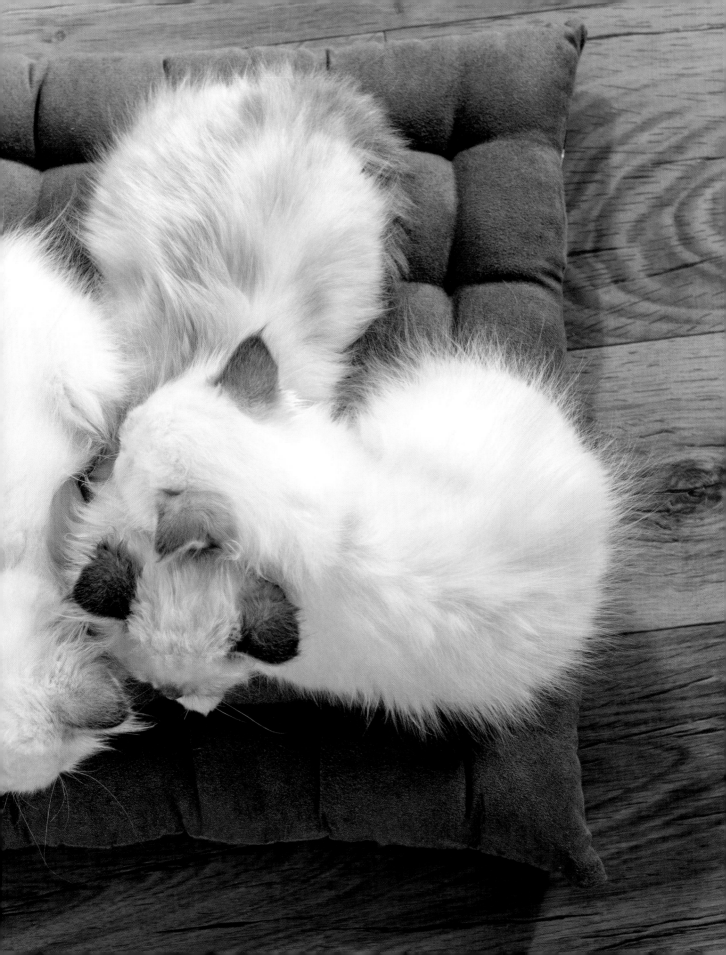

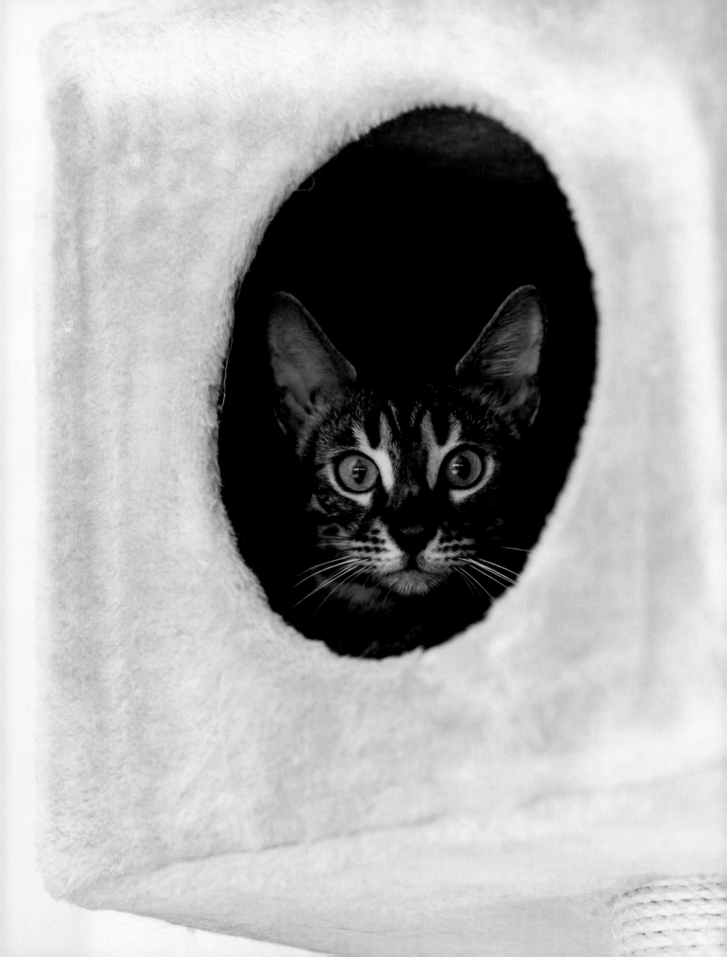

The Shy Cat

(or the Fraidy Cat)

Shy cats, who don't like strange people, have a certain similarity to divas. They are often overly anxious and suspicious and demand much sympathy and patience from their can openers. Among the house pumas, the fraidy cat always places enormous demands on a new cat owner. For they require a lot of time and, above all, opportunities to retreat.

One of these was little Mika, who came at three months to the home of my friend, whose children were still very small. They were terribly disappointed that the kitten would not let herself be petted but instead hid under the bed all day. She only came out at night, in order to eat and use the litter box. Fortunately the grownup can openers were relaxed and just let the kitten settle into her new home at her own pace. The first few days they left her alone and kept the bedroom door open at night. Cats feel much more secure if they can get to know their environment in the dark. Besides, it is generally peaceful at night because everyone is asleep.

A cat acquires her life-long character at an early age. How she will relate to people and other cats is determined between the second and seventh week of her life. Cats are seldom shy if they have positive experiences with people and if they and their mother are cuddled and played with. It is practically impossible to establish close relationships with wild cats who have had no experience with people at an early age. Another factor is whether the little fraidy cat's mother is herself shy. Cats learn everything important in life from their mothers. Also, there are hereditary factors determining whether a cat is trusting or not. →

Mika gradually lost her shyness. She still finds guests and strangers unsettling and withdraws to the cellar or attic when there are visitors. But she comes out and makes herself comfortable on the sofa once the barbarians have left. The oldest daughter broke through the shyness by devotedly making cat fishing rods and hiding places and inventing crazy circus games with Mika. She is herself a somewhat shy girl and domesticated her little cat by developing an affectionate relationship. As a result she is the fraidy cat's favorite—and that is one of the greatest distinctions you can ever achieve. 🐾

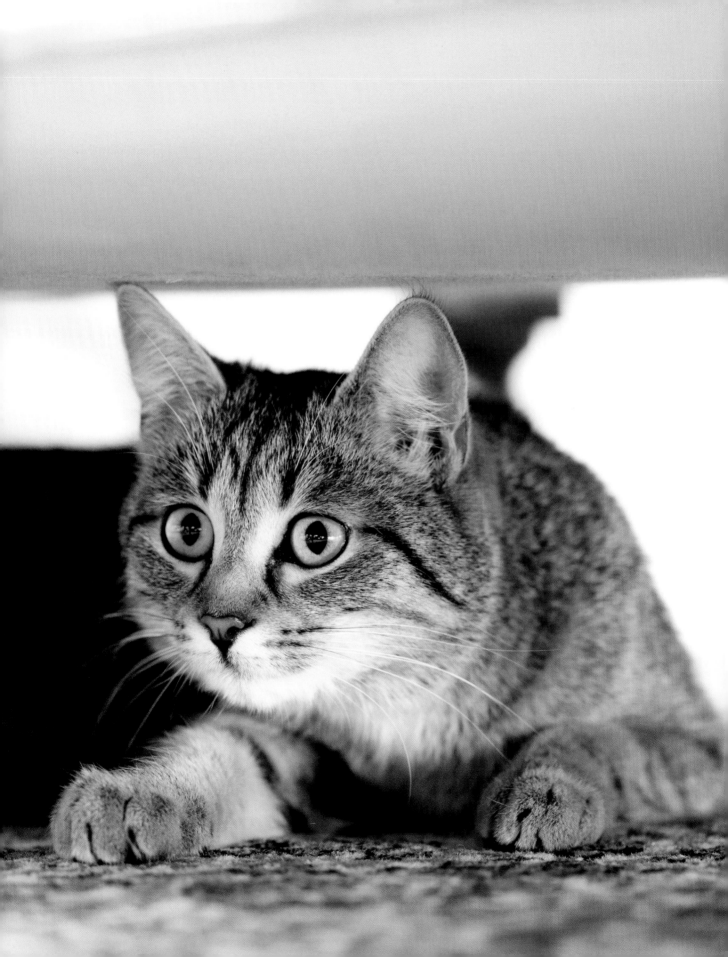

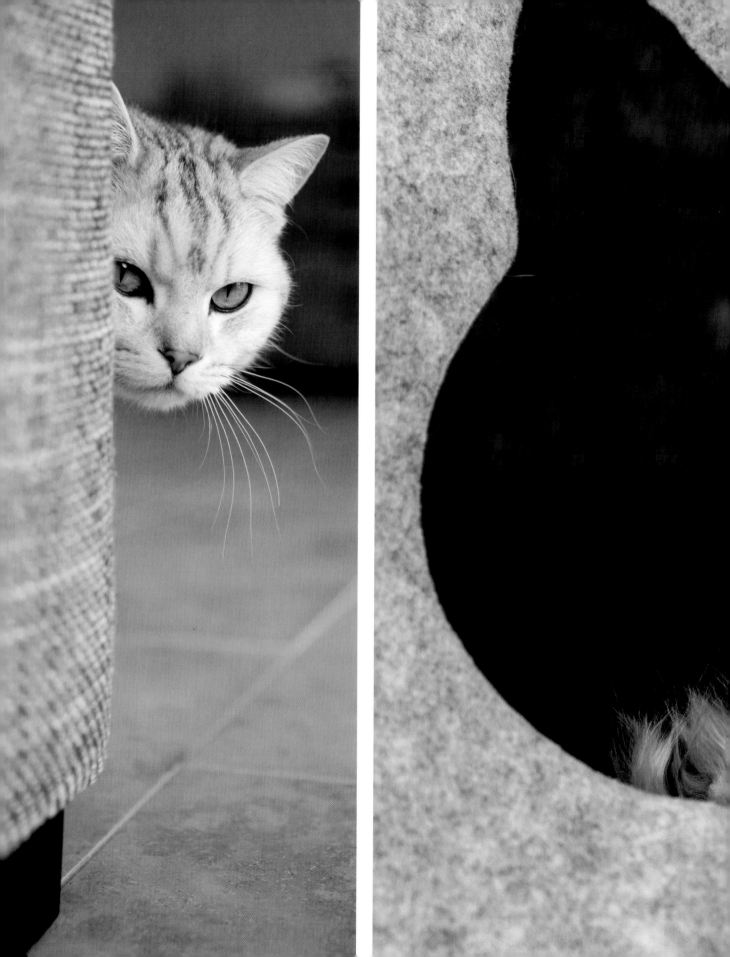

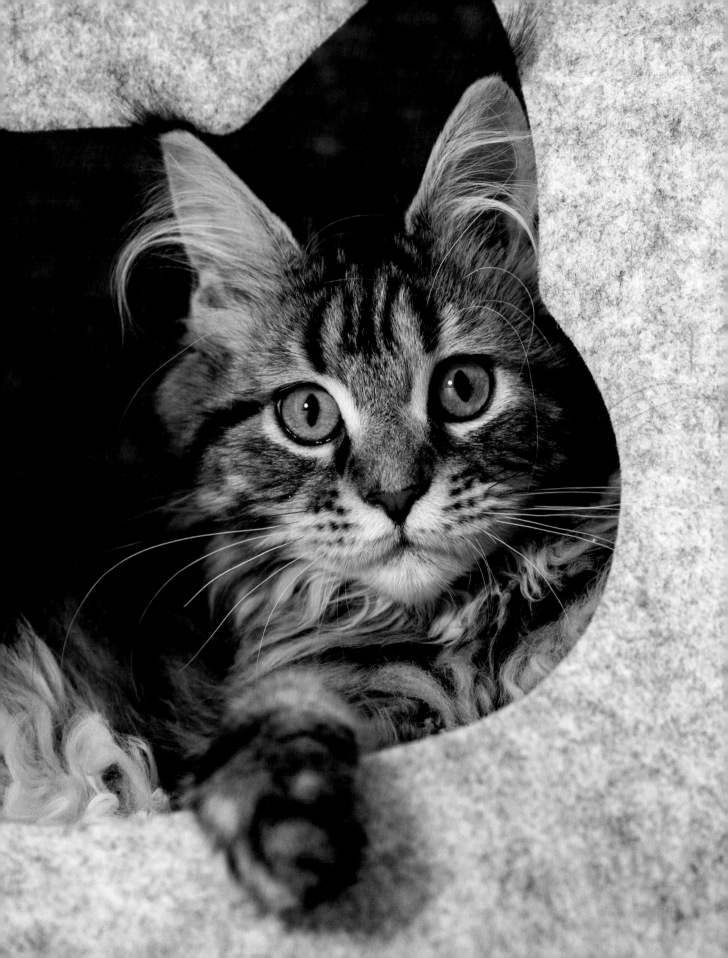

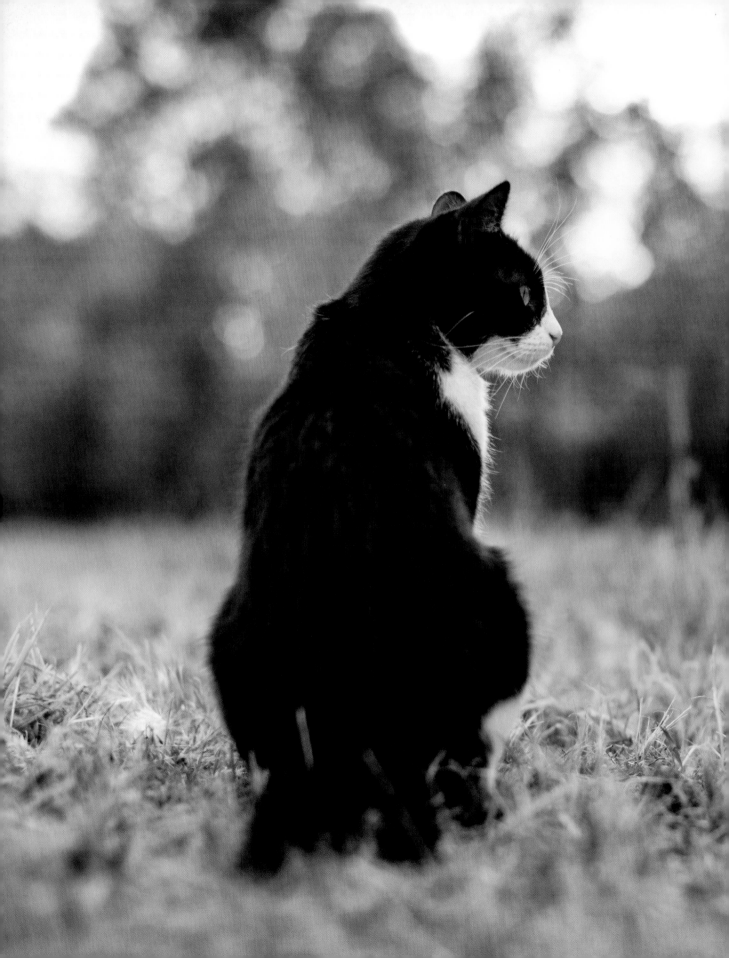

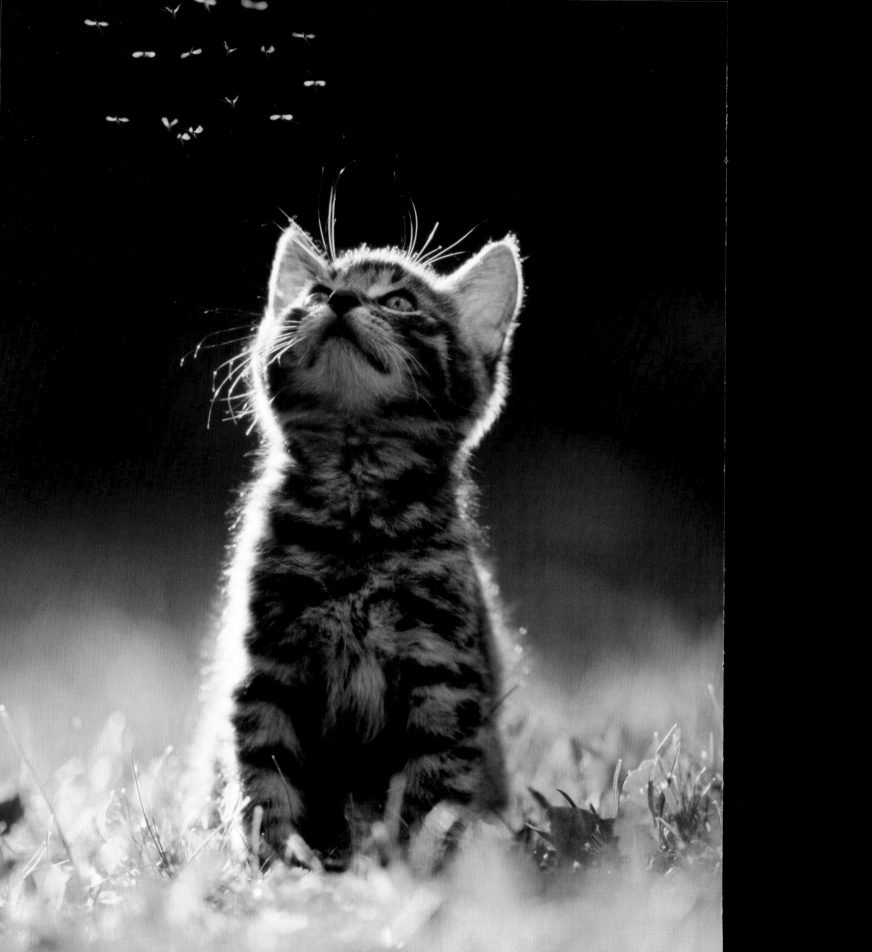

Anna Cavelius

Anna Cavelius, MA, studied philosophy in Munich, Siena, and Salamanca, and afterwards worked for an American magazine publisher. Since 1995 she has been a freelance lecturer, ghostwriter, and author of medical, lifestyle, and culinary articles. She has published many bestselling books on counseling and other topics. Her book, *Kluge Frauen und ihre Katzen*, (Intelligent Women and their Cats), was published in Germany. She is passionate about her family, friends, and cats as well as about the large and small things in life.

Cats who have worked on this book & their servant

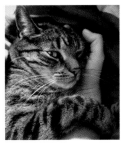

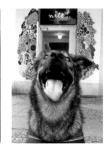

Thali & Sookie
Writing team

Petit
Editorial

Louis
Editorial

Karlo
Imaging

Nice
Design & Layout

Imprint

© 2016 teNeues Media GmbH & Co. KG

Photos: © Oliver Giel, www.tierfotograf.com, except for photos on the bottom of page 80 (private) and page 143 (private)
Cat icon (spine): © Noun 6725, created by Marco Hernandez from the Noun Project
Wool icon: © Noun 38202, created by Sitara Shah from the Noun Project
Paw icon: © Noun 96529, created by Lloyd Humphreys from the Noun Project

Introduction & texts by Anna Cavelius
Translation by Elizabeth Hughes Schneewind

Project management by Nadine Weinhold
Design & layout by Christin Steirat
Copyediting by Maria Regina Madarang
Production by Dieter Haberzettl
Imaging & proofing by David Burghardt

Published by teNeues Publishing Group
teNeues Media GmbH & Co. KG
Am Selder 37, 47906 Kempen, Germany
Phone: +49 (0)2152 916 0
Fax: +49 (0)2152 916 111
e-mail: books@teneues.com

Press department: Andrea Rehn
Phone: +49 (0)2152 916 202
e-mail: arehn@teneues.com

teNeues Publishing Company
7 West 18th Street, New York, NY 10011, USA
Phone: +1 212 627 9090
Fax: +1 212 627 9511

teNeues Publishing UK Ltd.
12 Ferndene Road, London SE24 0AQ, UK
Phone: +44 (0)20 3542 8997

teNeues France S.A.R.L.
39, rue des Billets, 18250 Henrichemont, France
Phone: +33 (0)2 48 26 93 48
Fax: +33 (0)1 70 72 34 82

www.teneues.com

ISBN: 978-3-8327-3330-8
Library of Congress Control Number: 2015958052
Printed in the Czech Republic